CLACTON-ON-SEA THEN & NOW

IN COLOUR

NORMAN JACOBS

The History Press

First published in 2012

The History Press
The Mill, Brimscombe Port
Stroud, Gloucestershire, GL5 2QG
www.thehistorypress.co.uk

British Library Cataloguing in Publication Data.
A catalogue record for this book is available from the British Library.

ISBN 978 0 7524 7112 9

Typesetting and origination by The History Press
Printed in India
Manufacturing managed by Jellyfish Print Solutions Ltd

CONTENTS

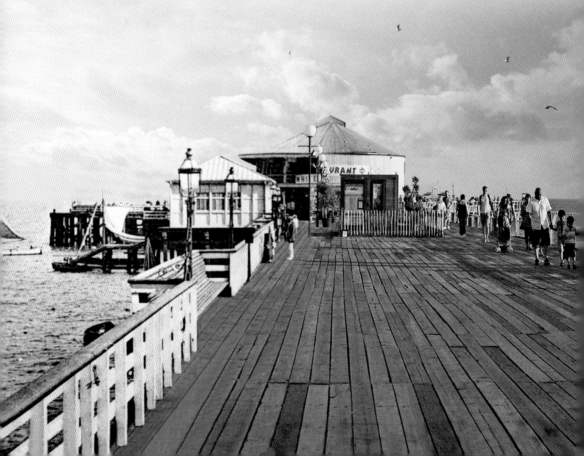

ACKNOWLEDGEMENTS

First and foremost I would like to thank my wife, Linda, who not only took forty-four of the forty-five modern photographs – for the most part risking life and limb by standing in the middle of the road (from where most old photographs seem to have been taken in the days before there was much traffic) – but also painstakingly selected the best ones from the dozens of examples she took and resized them for publication on her computer.

I would also like to thank Peter Underhay, not only for the photograph of the Horsefall family's farm but also for all the information that went with it and the modern comparative photograph.

Finally, thank you to all the members of the Clacton & District Local History Society, in particular Vic Miller and Roger Kennell, for all the help and support they have provided over the years and for all the information I have learnt from them.

ABOUT THE AUTHOR

Norman Jacobs is now retired after working at The British Museum for thirty-seven years. He founded and has been the chairman of the Clacton & District Local History Society for twenty-seven years. He also helps run the Clacton Museum. He was previously chairman of The Museums in Essex Committee and is currently secretary of the Essex Archaeological and Historical Congress. He gives talks on various aspects of Clacton's history throughout Essex and East London.

INTRODUCTION

Not counting the time 400,000 years ago when a band of wandering old Stone-Age settlers set up camp in an area somewhere between what is now the pier and Lion Point in Jaywick, Clacton-on-Sea has gone through four distinct phases before becoming what it is today.

Before 1871 there was no Clacton-on-Sea. The area was known simply as Clacton Beach and was named after the nearby inland farming village of Great Clacton. Much of the land destined to become the centre of Clacton-on-Sea was farm land. It was when this farm land was sold off to a developer called Peter Bruff that the real story of Clacton-on-Sea began as the town moved into 'phase two'. With the aid of the Woolwich Steam Packet Co., who agreed to finance Peter Bruff's plans for a new seaside resort, building in Clacton got underway. This phase lasted roughly until the First World War as Clacton's founding fathers put in place the infrastructure that was to lead to Clacton's third phase.

After a short interlude for the war, Clacton bounded into the 1920s ready to take its place as one of the leading seaside resorts in the country. By the outbreak of the Second World War Clacton was playing host to over 100,000 visitors per week, and boasted the largest pier in the country, a Butlin's Holiday Camp, six cinemas and ten theatres amongst its many other attractions. This phase of Clacton's history, as one of the top-ten seaside resorts in the country, lasted into the 1950s, but by 1960 the beginnings of phase four were being felt.

In common with most British seaside resorts, decline set in during the 1960s: people were growing more affluent and looking to go on foreign holidays instead of British trips. In Clacton's case, the situation was exacerbated by the 'Mods and Rockers' invasion' of Easter 1964. The final nail in the coffin of Clacton's reputation as a top seaside resort came in 1983 when Butlin's closed. During the general recession of the mid-1980s, the town suffered the highest unemployment rate of any town in the South East of England. It was a bleak period.

It's not easy to pinpoint any specific date and say that Clacton's decline went into reverse and that the town has 'now' arrived, but certainly over the last few years there has been a definite revival in Clacton's fortunes. The annual Air Show brings in tens of thousands of visitors, and on sunny days beaches such as the West Beach and the Martello Bay Beach are once again full of sun-seekers. With the work done by the Ball family and Billy Peake in the last couple of years to modernise the pier and the pavilion respectively, and the very real prospect of the Royal Hotel re-opening after many years of closure, this part of Clacton-on-Sea is once again becoming the lively heart of a thriving seaside town, as it was at its height.

THE OLD TOWN HALL

BY 1904, THE date of the photograph below, Clacton's first Town Hall had been built. The buildings comprised a bank on the ground floor, council offices upstairs and a theatre, the Operetta House, to the rear. The Town Hall had opened in April 1894 to house the Local Board of Health offices, but all Local Boards of Health were dissolved at the end of 1894 and their place taken by urban or rural

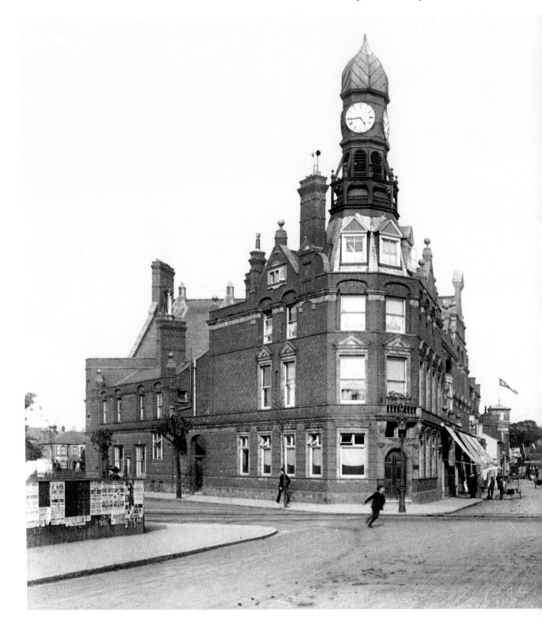

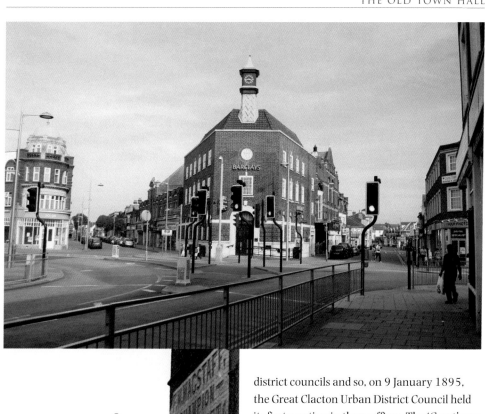

district councils and so, on 9 January 1895, the Great Clacton Urban District Council held its first meeting in these offices. The 'Great' was dropped within six months and the council vacated the premises in 1923.

AFTER THEY VACATED the premises – to move further up Station Road, to the spot where the Town Hall is today – the downstairs of the old Town Hall buildings remained a branch of Barclays Bank and the Operetta House was converted into the Tivoli Cinema. The whole building was badly damaged during the Second World War when, in May 1941, a lone raider dropped a bomb on the corner of Station Road and Rosemary Road. Much of the front of the building was blown away and the clock had to be pulled down. It wasn't until 1957 that the bomb-damaged building was replaced by the one currently standing on the spot and shown in this photograph.
(*Photograph by Linda Jacobs*)

STATION ROAD

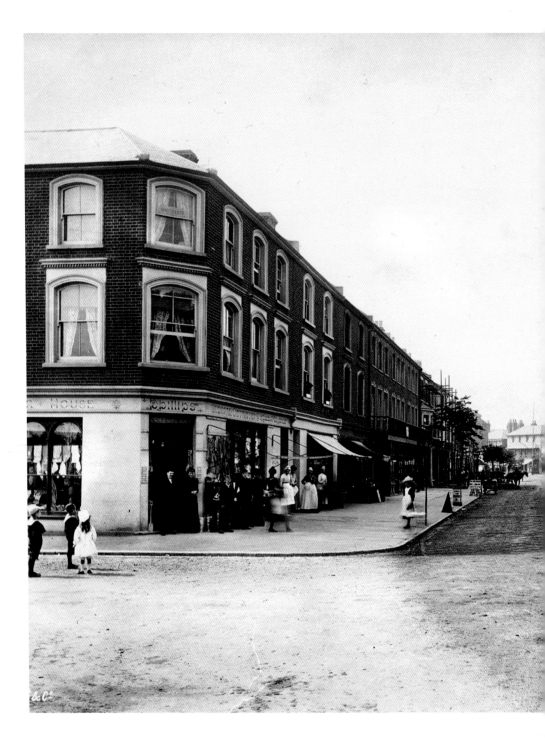

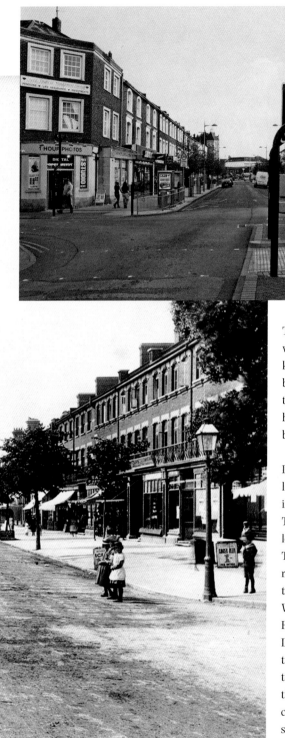

THE SHOP ON the corner of this 1891 view looking down Station Road was then known as Bayswater House and was owned by Mrs Phillips, a wardrobe dealer. It was on this site that Seaside House Farm – which had originally owned the land that was to become Clacton-on-Sea – stood.

IN THE PRESENT-DAY photograph (above) looking down Station Road, Bayswater House is now home to Snappy Snaps, photographers. The building suffered at the hands of the same lone bomber who destroyed much of the old Town Hall in May 1941 and was completely rebuilt after the war. Wagstaff's Corner, on the opposite side, suffered the same fate. Wagstaff's was originally built as Walbrook House to house the original Clacton-on-Sea Land Co. and Pier Co. By 1900 it had been taken over by Frederick Wagstaff, a prominent town councillor and twice chairman of the council, who opened a tobacconist and confectioner's shop. As can be seen, the shop still bears his name to this day.
(*Photograph by Linda Jacobs*)

OUTSIDE BATTY'S

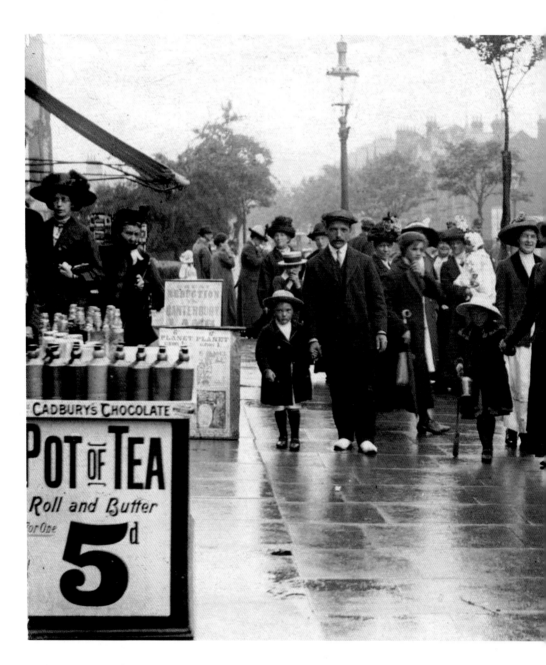

THOSE WERE THE days! A 'Pot of Tea, Roll and Butter for one, 5*d*'. This is a view of Station Road looking towards the old Town Hall, *c.*1914. The café in question was A Mazzoleni's at No. 31. The photograph itself was taken by H. Batty, photographer, from outside his shop next door at No. 29.

THREE DOORS DOWN from Wagstaff's Corner, the site of Mazzoleni's café is now the Card Factory shop; looking across to the opposite corner of High Street and Station Road, the Scope charity shop now occupies the open space shown on the old photograph. This is part of Arcade

Buildings, built on that corner in the 1930s. When the Barclays Bank building was bombed and out of commission for sixteen years, they opened up a branch on this corner. At the time this photograph was taken (October 2011), a 'To Let' sign was posted on the wall of the old Town Hall. If Barclays Bank do move out it will break the tradition of Barclays Bank or one of its predecessors being on that spot since 1894. (*Photograph by Linda Jacobs*)

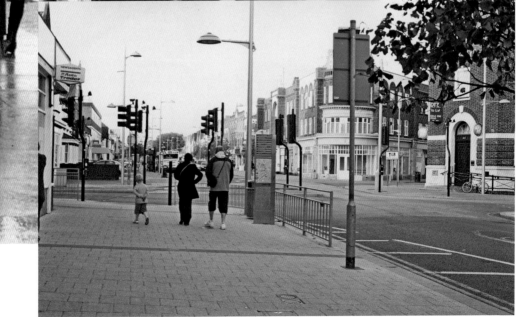

ROSEMARY ROAD

AN 1897 VIEW of the pair of houses on the corner of Rosemary Road and The Grove (right). In 1901 the ground floors were converted into a parade of shops. Unfortunately, this was the same year that Electric Parade opened and the venture suffered financially as a result.

IN SPITE OF losing out to Electric Parade, the corner still continues to this day as a small shopping parade. Behind the shops in the modern photograph the original pair of houses can still be made out, although the rural setting has long since disappeared and an additional wing has been added on to the back of the house on The Grove frontage. The photographic

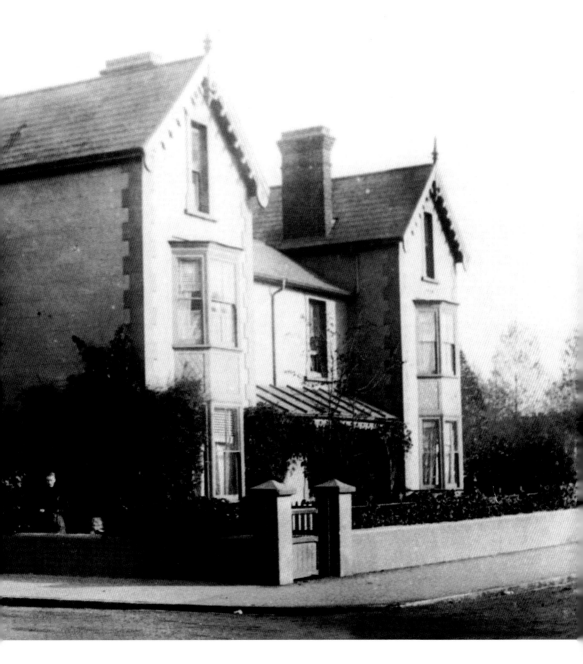

shop on the corner, now owned by Roberta Ross, was for many years run by Alex Bareham, a photographer who himself recorded many of the changes in Clacton's history.
(*Photograph by Linda Jacobs*)

TRINITY METHODIST CHURCH

BELOW IS THE corner of Rosemary Road and Pier Avenue some time between 1881, when the water tower was built, and 1887, when a schoolroom was added to the Wesleyan church. The water tower was acquired by the council in 1899 when it bought the Gas & Water Co.: it was 101ft high and held 30,000 gallons of water. In 1962 the council handed over the water supply to the Tendring Hundred Waterworks Co., who closed the tower down in 1968 and demolished it shortly thereafter.

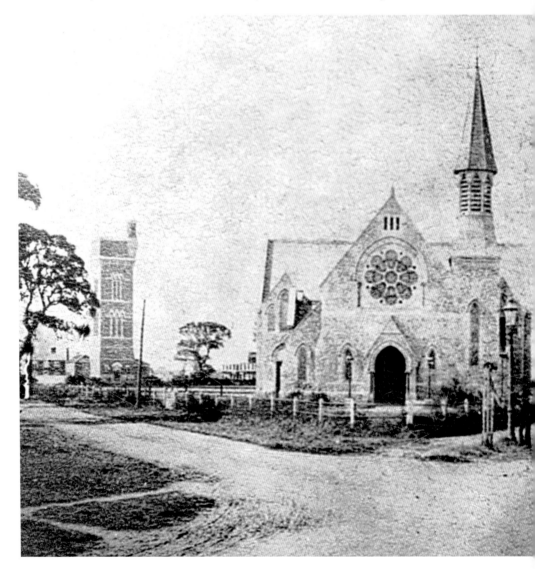

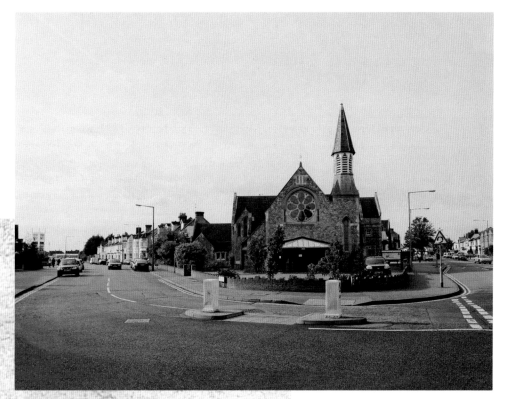

TRINITY CHURCH WAS opened on 14 August 1877 as the Weslyan church and could accommodate 500 people at a time when the total population of Clacton-on-Sea was less than 500. The schoolroom to the rear of the church was opened in 1887, and within one year had 225 children on the register. Trinity church is no longer an isolated building in a rural setting but is now at the centre of a busy, built-up junction. In the background, the water tower has been replaced as a landmark by the Waterglade Retail Park sign, indicating the large retail shops such as Morrisons, Iceland, Carpet Right, Next, Halfords and Homebase on the site.
(*Photograph by Linda Jacobs*)

ELECTRIC PARADE

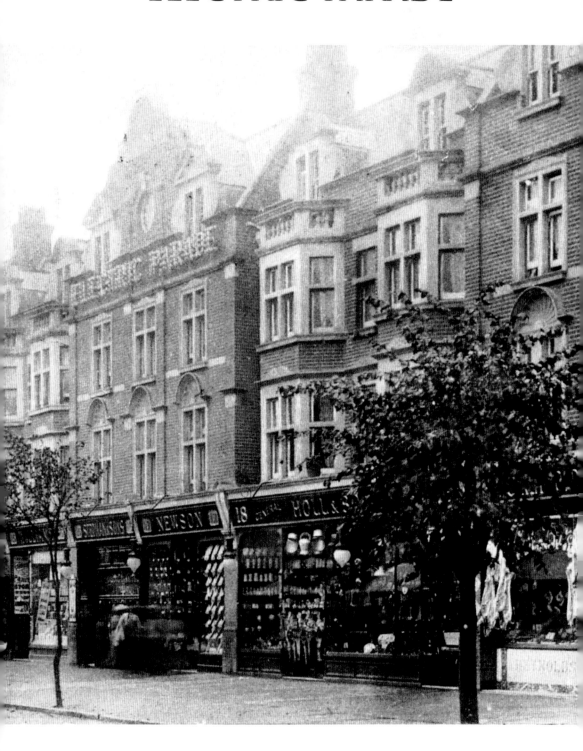

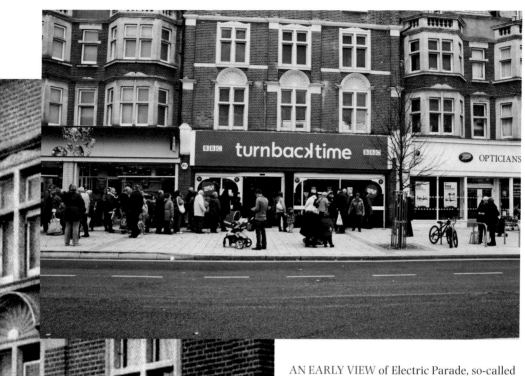

AN EARLY VIEW of Electric Parade, so-called because it was the first part of Clacton to be lit by electric light. On the left of the old photograph is Newson's Outfitters, the last shop to remain in the Parade before its removal, over 100 years later, to new premises in Rosemary Road.

ALL THE SHOPS in the old photograph have changed hands many times over the years. Cutforth Fancy Goods' Shop, for example, became Roe & Son's stationery shop and was then incorporated into the next-door shop, Barker's butcher, formerly Reynolds', closing in 1933 and re-opening in the 1950s as the Co-op shoe shop – and then, in the 1980s, the Co-op jewellers'. The jewellers' closed in 2010, and since then the shop has been unoccupied. However, in November 2010 it played a major role in the BBC One television series *Turn Back Time – The High Street*, when, for three days, it was converted into a 1930s shop.
(*Photograph by Linda Jacobs*)

WHSMITH

THE MAIN POST office and staff in 1907 (below). From 1901 until 1927, the post office was situated at No. 9, Electric Parade, at which time it moved to its present site in the High Street. The postmaster in the centre of the photograph is Mr W.T. Pinkney, who had been appointed

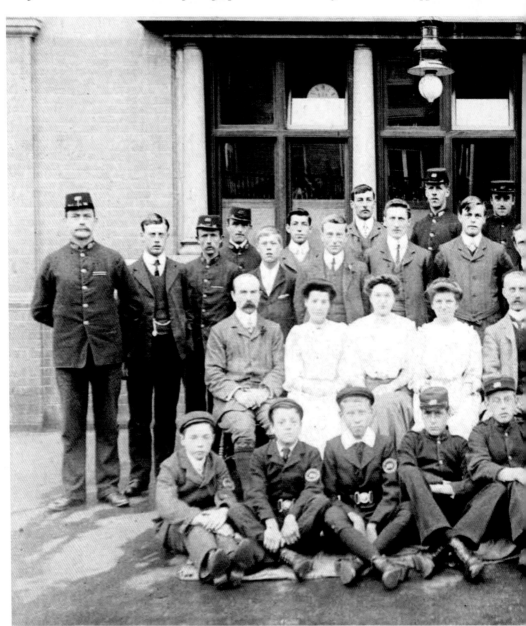

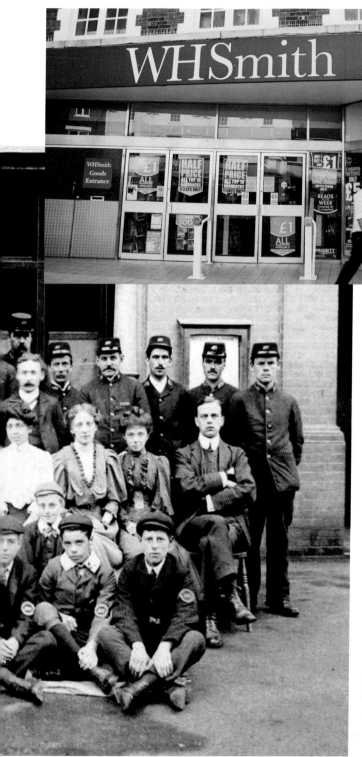

in 1906. The man standing
second from left is Mr J. Clark,
who later became a JP.

WHEN THE POST office
moved to its present site in
the High Street in 1927,
WHSmith took over the
premises. They already had
a shop on the other side
of Electric Parade (which
curiously was still called Pier
Avenue) but closed it when
the new shop opened. In the
early days, WHSmith also
operated a 'circulating library'
from the premises. WHSmith
holds the honour of being the
oldest shop in Clacton still
in the hands of its original
owners and still on the same
spot, and will celebrate
eighty-five years in 2012.
(*Photograph by Linda Jacobs*)

CHRISTMAS TREE ISLAND

ON THE RIGHT of this 1950s view (right), looking up Electric Parade from the junction with Station Road, is an elm tree, the town's last reminder of its fairly recent rural past.

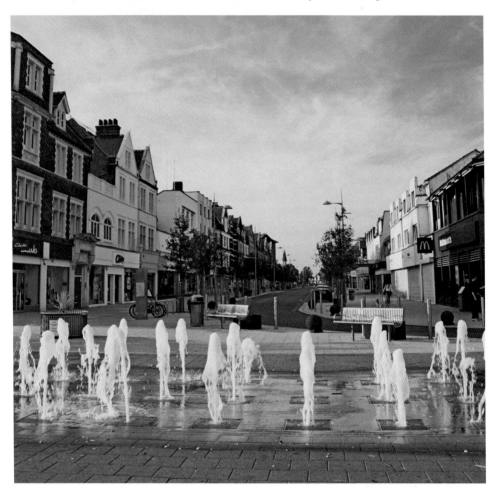

DURING THE LAST ten years the whole of the island at the corner of Station Road and Pier Avenue (formerly Electric Parade) has been redesigned. The elm tree finally succumbed to Dutch elm disease and the island, known as Christmas Tree Island, was widened to block off any through route between Station Road and the lower part of Pier Avenue. In 2007 a new feature was added, the fountain shown in the foreground, which has been dogged by controversy ever since, at one time even being turned off because of fears over the water's quality. It is now, however, established as a permanent feature of the town centre.
(*Photograph by Linda Jacobs*)

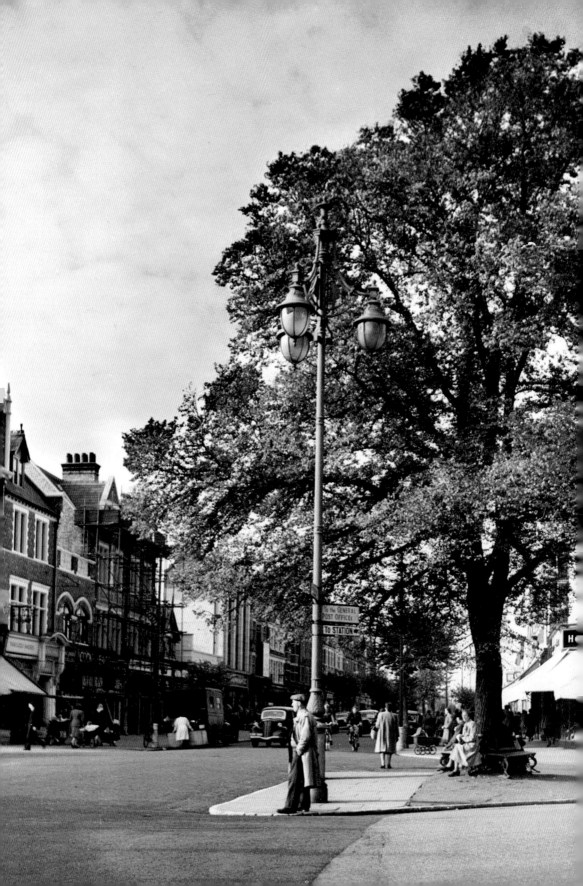

McDonald's Corner

IN THE LATE 1930s photograph below, taken from the same junction, looking the other way up the tree-lined Station Road, it is evident that the town clock was a prominent feature of Clacton before the war.

ONCE AGAIN THE change in the road layout and the loss of the elm tree at the junction of Pier Avenue and Station Road are evident in the modern photograph. Grimwade and Clark, high

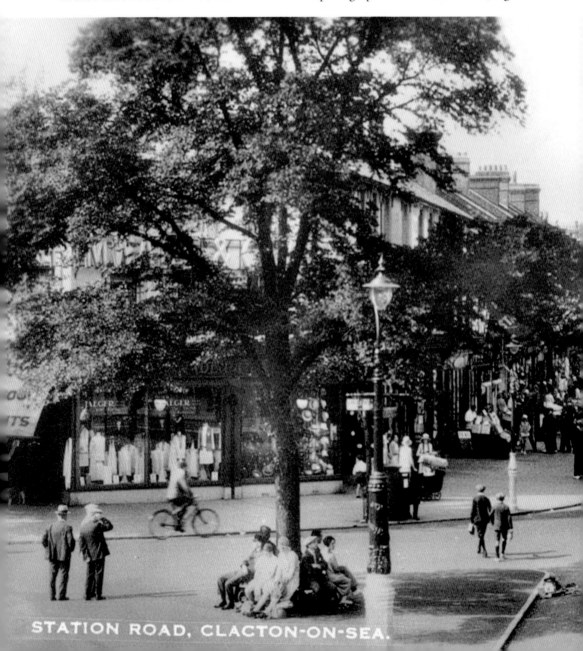

STATION ROAD, CLACTON-ON-SEA.

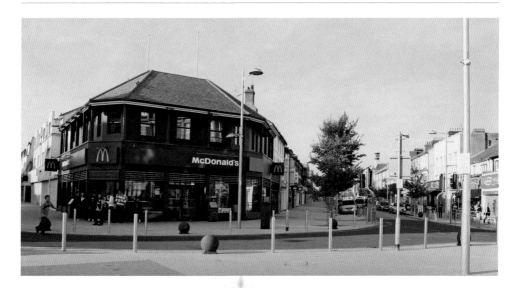

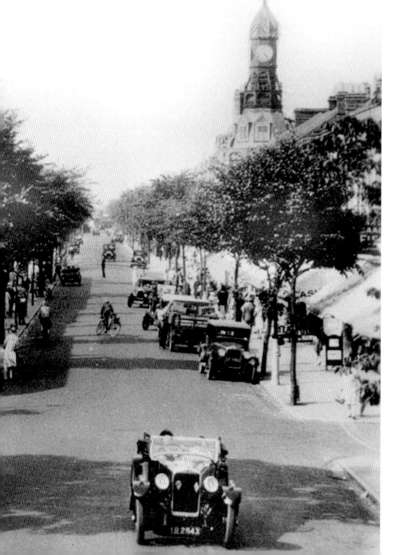

class-outfitters and shoe shop, stood on the junction for about eighty years until it was closed and the original building knocked down in 1984 to make way for the McDonald's restaurant now occupying the spot, which is no longer obscured by the tree but stands out as a major landmark. Although still visible in the background, the new town clock is not as prominent as the original one.
(*Photograph by Linda Jacobs*)

WEST AVENUE

CLACTON'S FIRST PURPOSE-BUILT cinema, The Kinema – later the Kinema Grand – was built in 1913 in West Avenue. The photograph below dates from just before the First World War. The Kinema Grand was demolished in 1962.

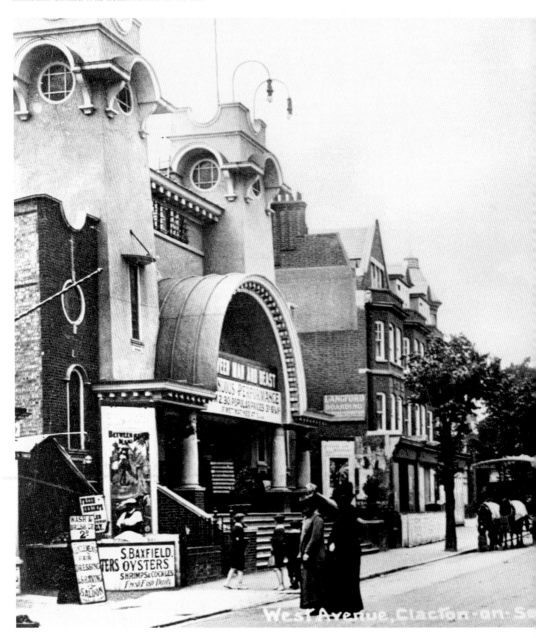

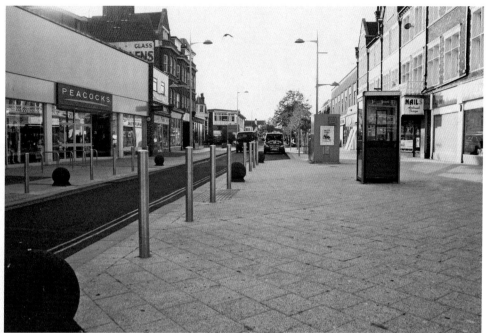

AFTER THE KINEMA Grand was demolished, the spot it occupied on West Avenue changed hands, with various different shops taking its place. The first was Fine Fare supermarket, noted for giving away one S&H Pink Stamp for every 6*d* spent (their rival to the better known Green Shield Stamps). When a customer had collected sufficient stamps in thier collectors' book, they could claim merchandise from a catalogue or S&H Stamps' shop. It is now the site of Peacocks. The railings in the bottom right-hand corner of the old photograph surrounded the entrance to the underground toilets below Christmas Tree Island. These were filled in when new toilets were opened in Rosemary Road in the 1980s and then completely demolished when the fountains were built.
(*Photograph by Linda Jacobs*)

MARKS & SPENCER

SHORTLY AFTER MOVING to Pier Avenue in 1934, Marks & Spencer expanded the shop and created an entrance at the rear on to West Avenue. The photograph on the right, taken in 1935, shows the back entrance being widened.

NOW ONE OF the oldest shops in Clacton, along with shops like WHSmith, Burton men's clothing shop, Boots and the Co-op, it seems that it is now mainly the multi-national chains that survive the longest (rather than family-owned shops, as was the case up to a few years ago when shops like Saltmarsh and Lewellen's closed and Newson's Outfitters moved). The back

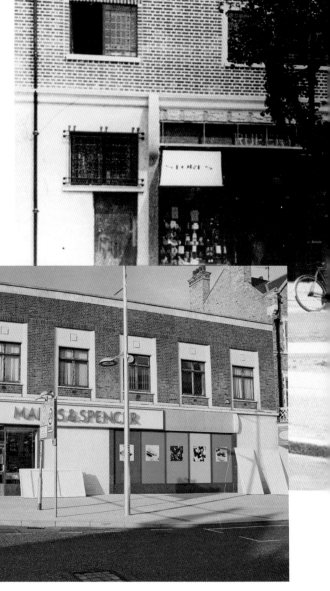

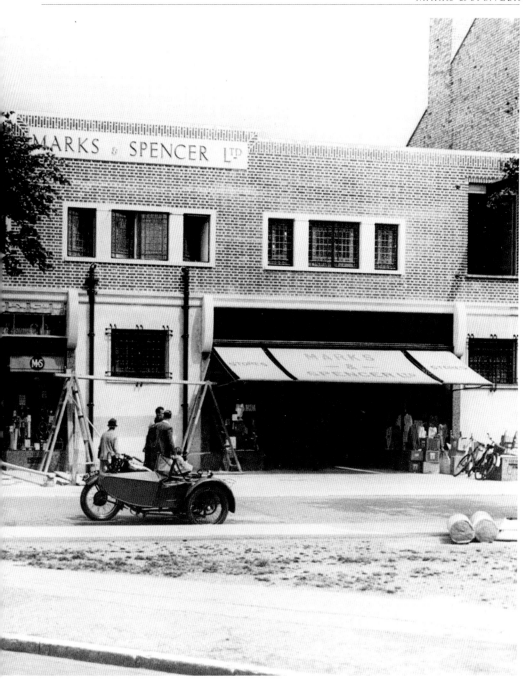

of the Marks & Spencer building in West Avenue has not changed, though part of the building was damaged by incendiary bombs during the Second World War. However, the name has moved down to a lower level and the second entrance – shown in the old photograph – has now been closed up again. (*Photograph by Linda Jacobs*)

THE ODEON

A NOSTALGIC VIEW from around 1950, looking along Agate Road towards the Odeon – which, in its day, was the last word in luxury cinema and one of the large cinemas the chain built all over the country in the 1930s. Opened in 1936, it closed in 1983, by which time it had been renamed 'the Salon'.

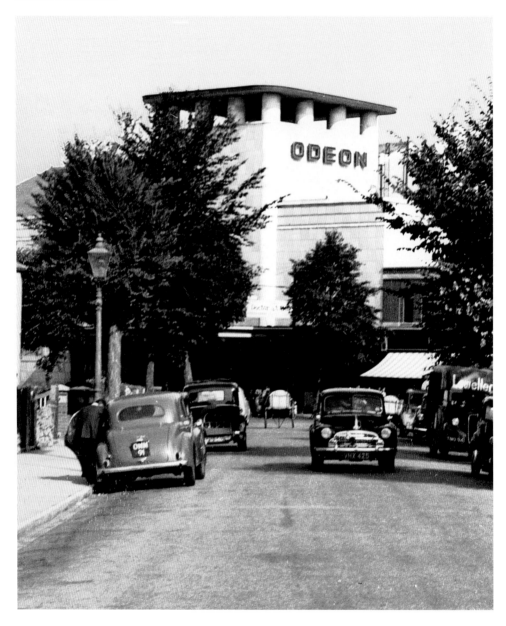

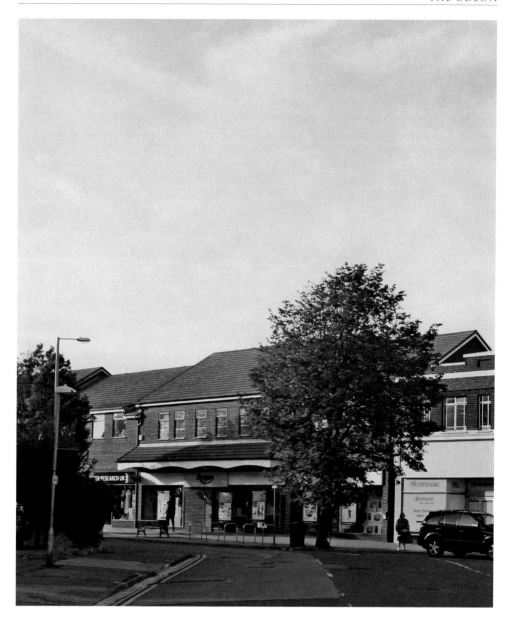

AFTER ITS CLOSURE in 1983, the building, which also included a small independent toy shop, was completely demolished in 1984 and a row of shops built in its place, which stood empty for eighteen months before finally being let. The most prominent of the new shops was a branch of Argos – which ironically, given what had happened when the Kinema Grand closed, had started out as a Green Shield Stamp redemption centre. To the right of the Odeon was the back entrance to Woolworths, which arrived in Clacton in 1926 and closed down when Woolworths as a company went into administration at the end of 2008. The site is now occupied by a branch of 99p Stores. (*Photograph by Linda Jacobs*)

THE PUBLIC HALL, PIER AVENUE

THE LARGE BUILDING on the left of this 1920s view of Pier Avenue was the old Public Hall, built by the town's pioneers in 1877. Much of the building was later occupied by Lewellen's ironmonger. On the right is the booking office for National Coaches, with boards outside advertising half-day and day trips to local places of interest.

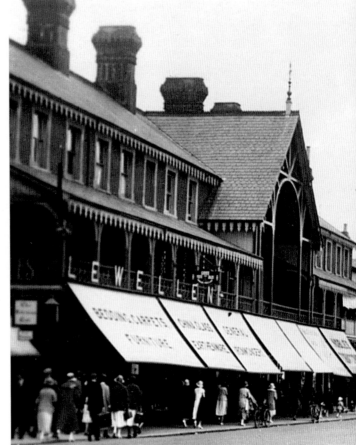

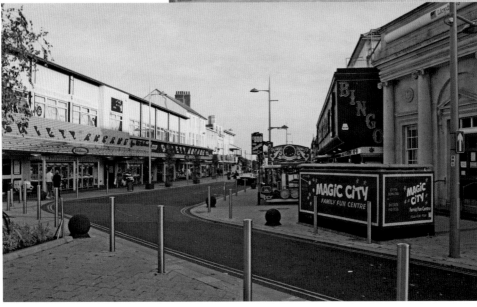

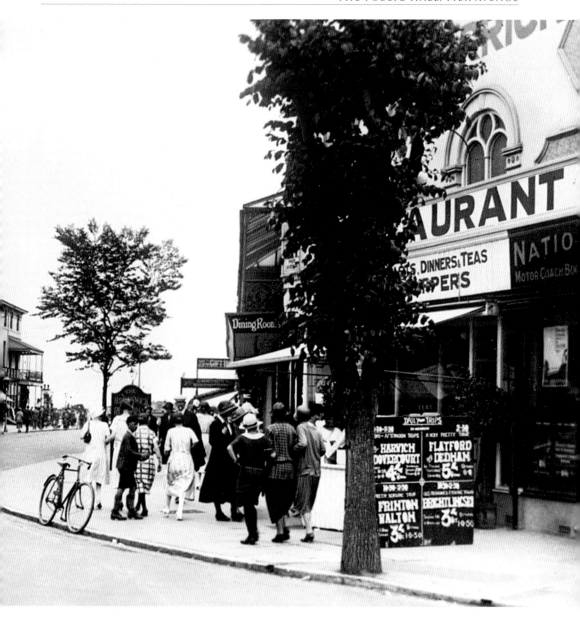

THE PUBLIC HALL and most of the surrounding buildings were destroyed in a disastrous fire
that occurred on 4 June 1939. The fire began just before 3.00 p.m. on a Sunday afternoon,
probably in Lewellen's paint store behind the shop. It quickly took hold and raged for some three
hours before being finally brought under control. BBC Radio broadcast regular bulletins on the
progress of the fire and it took up the whole of the front page of the *Daily Mirror* the following
day. It was probably the biggest event in Clacton's history. Because of the outbreak of the
Second World War shortly afterwards, the shops were not rebuilt until the early 1950s.
(*Photograph by Linda Jacobs*)

FOYSTER'S

HENRY FOYSTER OPENED his dining and tea rooms in Pier Avenue in the late 1890s. They lasted until well after the Second World War. Henry Foyster had two other shops: one in Rosemary Road and one on the other side of Pier Avenue next to the Brunswick Hotel, now Magic City.

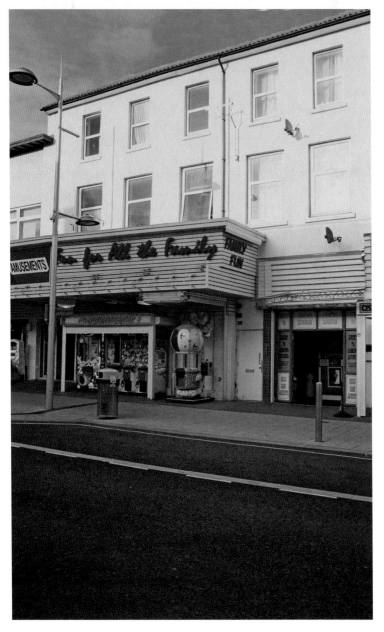

THANKS TO A sudden change of wind at about 5.00 p.m. on the afternoon of the famous fire, not all of Foyster's Restaurant was destroyed, though the roof was badly damaged when part of it was deliberately demolished by the fire brigade in an earlier attempt to stop the fire spreading. Much of the downstairs and the first-floor dining room were unharmed by the fire but suffered considerable water damage from the fire brigade's hoses. Nevertheless, part of the original building is still standing and has been combined with the new buildings as part of the Gaiety Amusement Arcade. (*Photograph by Linda Jacobs*)

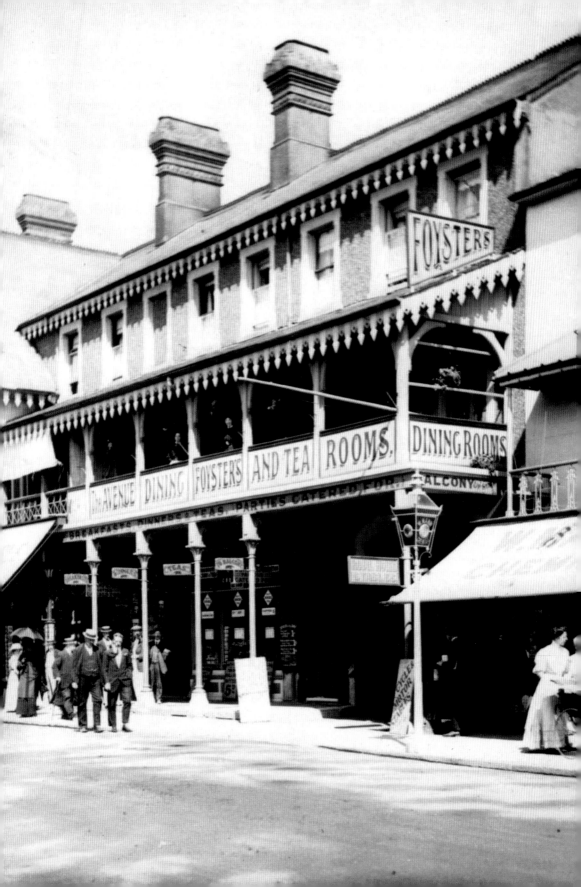

PIER AVENUE

ON THE RIGHT of this busy Edwardian scene below, at the junction of Pier Avenue and Marine Parade, is the Royal Hotel. Just outside the Royal Hotel is a policeman who was probably on traffic duty, although his services don't seem to be much in demand.

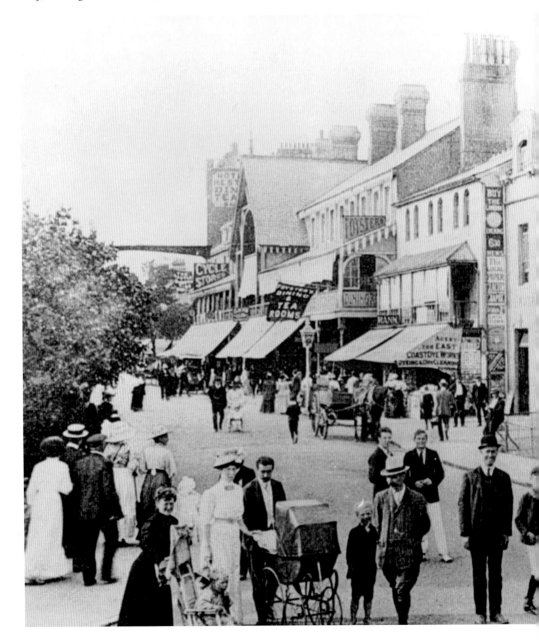

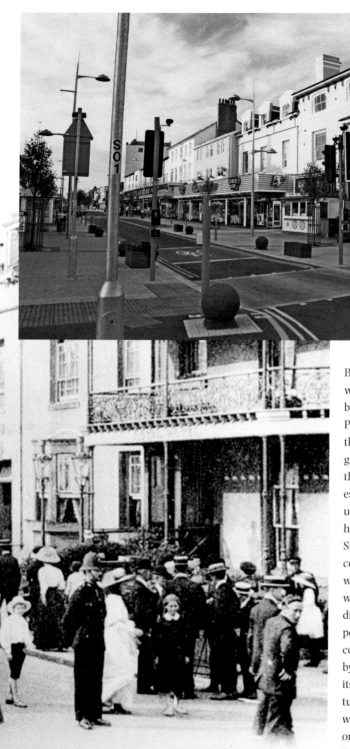

BECAUSE OF THE change of wind mentioned overleaf, the buildings at the lower end of Pier Avenue were saved from the fire, though there was great concern early on over the Royal Hotel's garage – especially as it contained an underground storage tank holding 500 gallons of petrol. Staff and other volunteers covered the whole area with wet carpets to try and prevent what would have been a disastrous explosion. The policeman on point duty at this corner has now been replaced by traffic lights, while the road itself has been narrowed and turned into a one-way street with an entrance for vehicles only from West Avenue. (*Photograph by Linda Jacobs*)

TOM PEPPERS

THE CORNER HOUSE Café on the corner of Pier Avenue and Marine Parade, seen below in the 1920s, was a very popular eating place throughout the inter-war and immediate post-war years.

ACROSS ON THE other side of the road, at the bottom of Pier Avenue, the building on the corner has undergone a number of changes of use, though the building is the same one. It was one

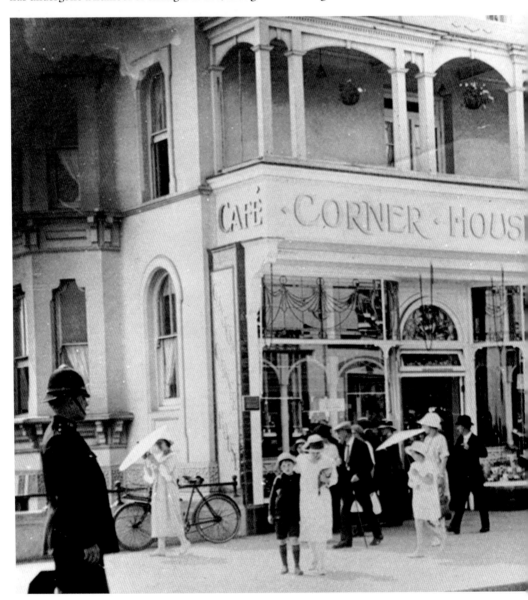

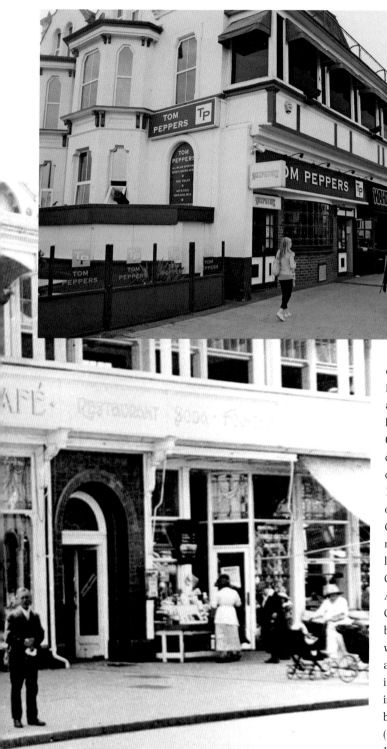

of the first to be erected in Clacton – as far back as 1876, when it was known as Clarence Villa. Originally a private dwelling, it began its commercial life in the 1880s as the Clacton office of the *Colchester Gazette*, Clacton's first newspaper office. It was later converted into the Clarence Restaurant. After its spell as the Corner House Café between the wars, it was converted into an amusement arcade in the late 1940s and is now the home of a bar, Tom Peppers. (*Photograph by Linda Jacobs*)

PIER GAP

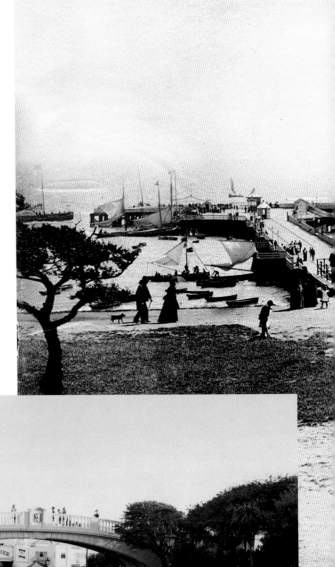

THE PHOTOGRAPH ON the right
was taken around 1890 in the days
when Pier Gap was lined by shops.
These were swept away in 1914 when
Clacton Council decided to implement
a 'general beautifying programme'
and replaced the shops with gardens
and the Venetian Bridge.

A GRAND CEREMONY was laid
on in 1914 to declare the Venetian
bridge officially open. One of the
specially invited guests, the Mayor
of West Ham, congratulated Clacton
Council for carrying out the work by
direct labour and for 'replacing the
winkle and eel-pie shops previously
down either side of the pier gap with
beautiful flower beds and the bridge

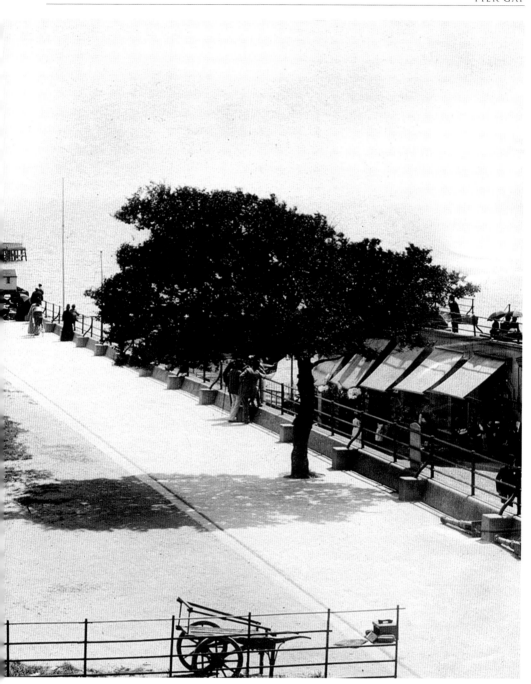

which stretched from cliff to cliff.' It was the last major work carried out in Clacton before the First World War and contributed to Clacton's status as one of the country's leading seaside resorts in the 1920s and '30s, as the bridge was to become – and still is – one of Clacton's major landmarks. (*Photograph by Linda Jacobs*)

ST OSYTH ROAD

THE SHOP IN the foreground on the corner of Warwick Road and St Osyth Road was one of Clacton's longest-lived businesses: Saltmarsh and Son. Starting out as a grocery shop in 1893, a sub-post office was added in 1902. The photograph below dates from about 1905.

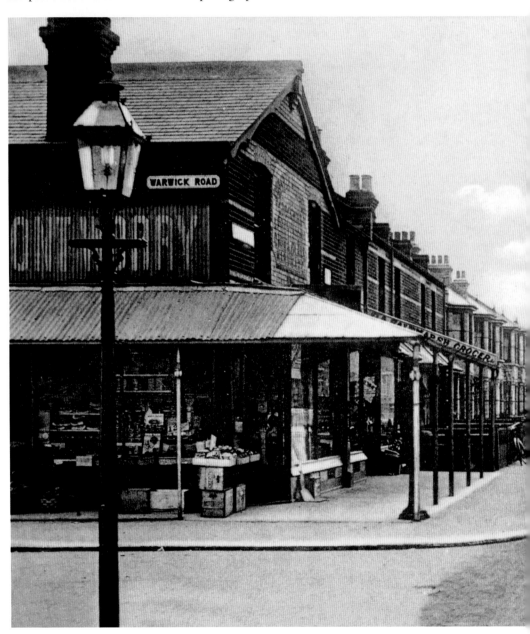

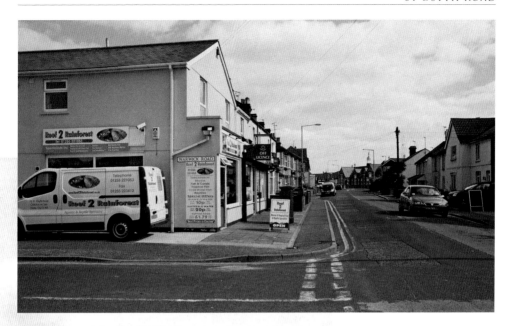

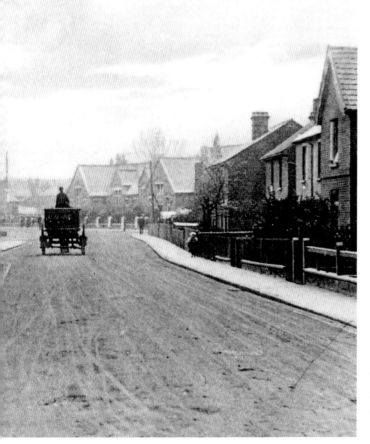

NOT LONG AFTER
Saltmarsh's centenary in
1993, the last remaining
Saltmarsh, Ronald, retired and
the business was sold. It is now
'Reef 2 Rainforest', aquatic
and reptile specialists. Only the
pillar box outside reminds the
passer-by that it was once one
of the busiest sub-post offices
in Clacton. St Osyth Road
School opened a year after
Saltmarsh's. This can just be
made out in the background
of the photograph above,
particularly the white
domed spire, which used to
house the school bell. This
too just made its centenary
before moving off to become
Oakwood Infants' School in
Windsor Avenue. The building
remains open now as an adult
education centre.
(*Photograph by Linda Jacobs*)

ST JOHN'S HOUSE AND THE MANSION HOUSE

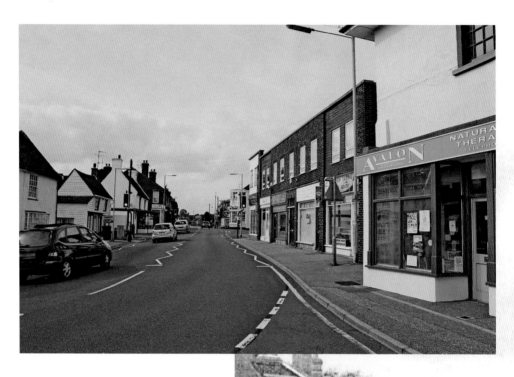

ST OSYTH MAIN Road (now St John's Road) during the Edwardian period (right), showing E. Culham & Son, wine, spirit and beer merchants, occupying the building known as St John's House. This was built in the early nineteenth century and at one time was home to Henry Finer, first chairman of Clacton Urban District Council and owner of the first grocery shop in Clacton-on-Sea.

TODAY, ST JOHN'S House is occupied by Avalon Natural Therapeutics, 'Healing the Natural Way'. In the centre of the photograph, the tall white building on the corner of St John's Road and North Road stands on the site formerly

occupied by the Mansion House, demolished in 1966 after having fallen into a poor state of repair. Built in the early eighteenth century, it was originally the home of the Field Family, said to be the richest family in Great Clacton. By the time of its demolition it had been split into three separate dwellings with an antique shop on the ground floor. There is now a modern block of shops on that corner. (*Photograph by Linda Jacobs*)

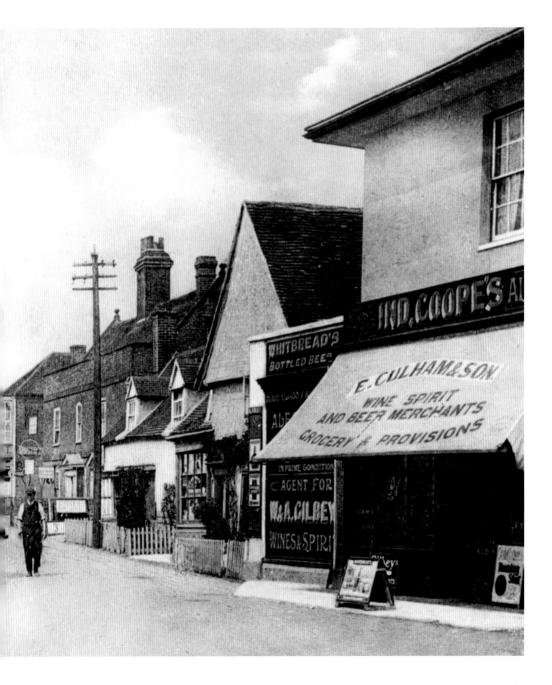

THE OLD HOUSES,
GREAT CLACTON

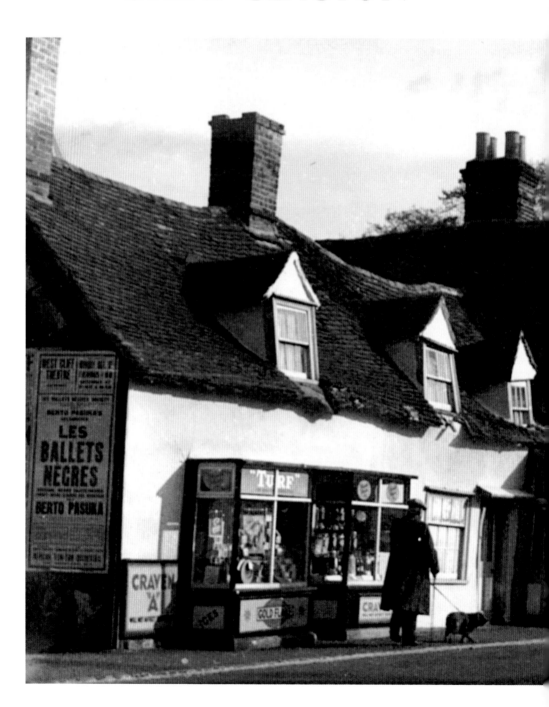

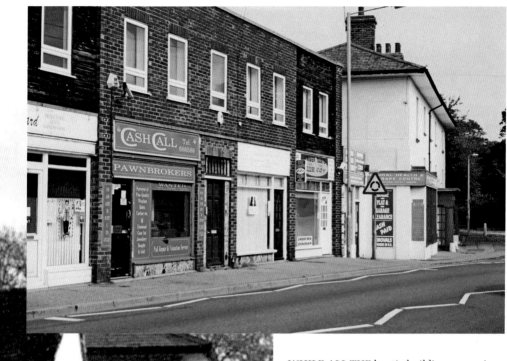

WHILE ALL THE hectic building was going on in the new town of Clacton-on-Sea, the old village of Great Clacton continued on its peaceful way. This picture from the 1950s shows how little it had changed for two or three centuries, apart perhaps for the advertisement for the West Cliff Theatre on the wall.

BY THE TIME of the modern photograph, however, change had finally come to the ancient village. At the same time the Mansion House was demolished, the old shops at the centre of Great Clacton were also demolished and replaced by a new row of shops. By the 1960s the new town of Clacton-on-Sea had completely engulfed the old farming community of Great Clacton within its boundaries. However, it is still true today that the centre of the old village manages to retain its own separate identity and small shopping centre. (*Photograph by Linda Jacobs*)

45

THE QUEEN'S HEAD

A PEACEFUL SCENE at the Queen's Head at about the turn of the twentieth century can be seen in the photograph below. Mr Pigg, the owner of the Queen's Head and also the village blacksmith, is the rather large gentleman in the middle of the three standing on the left.

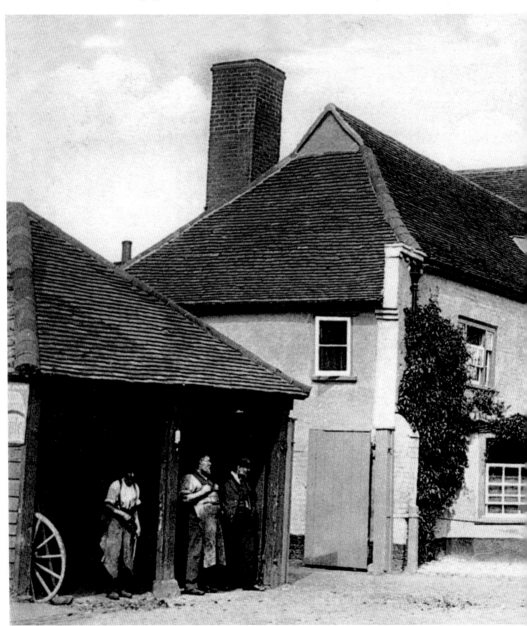

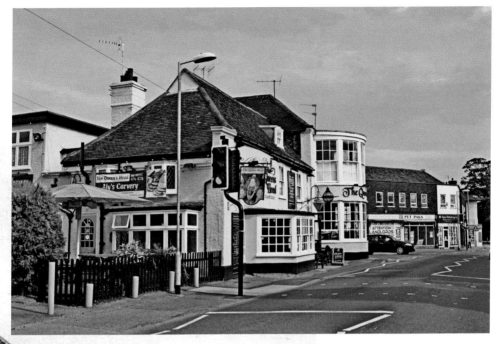

CLACTON'S OLDEST PUBLIC house, the Queen's Head, is still going strong today and still easily recognizable as the building in the earlier photograph. With the decline in horse-drawn traffic and the rise of motor traffic in the twentieth century, the smithy was closed down and turned into the Queen's Head's beer garden and car park. The change from rural calm to busy road is emphasized by the replacement of the horse-drawn carriage in front of the pub in the old photograph with a traffic-light controlled pedestrian crossing. In the background, the modern block of shops on the site of the old Mansion House can be clearly seen.
(*Photograph by Linda Jacobs*)

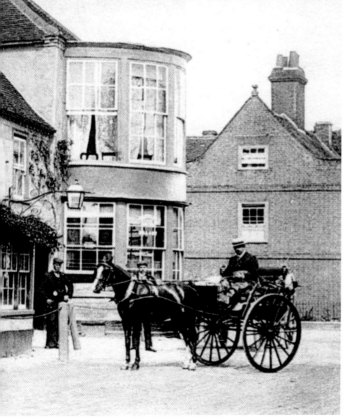

THE SHIP

THE SHIP INN, shown below in the early years of the twentieth century, dates back to around 1500, and is possibly the second oldest building still standing in Clacton after St John's church. Originally a yeoman's cottage, it became an inn in the early eighteenth century and was bought by John Cobbold in 1800.

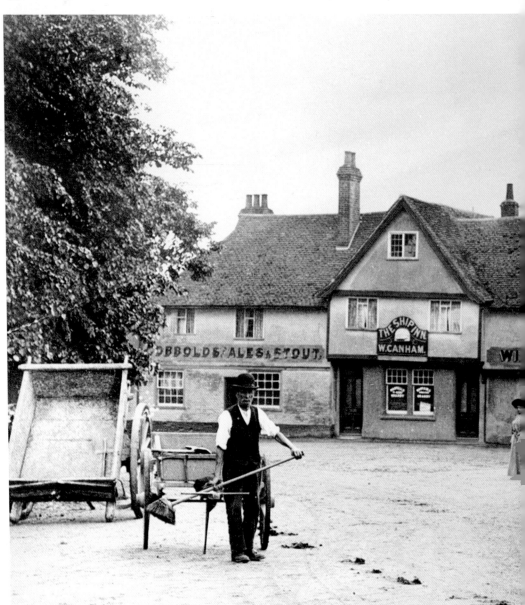

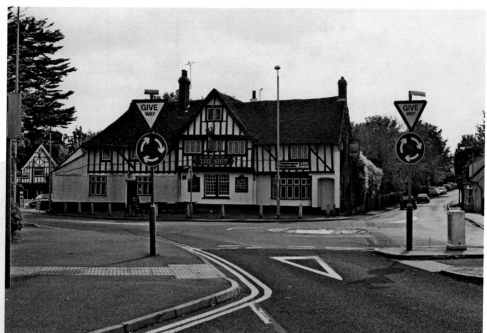

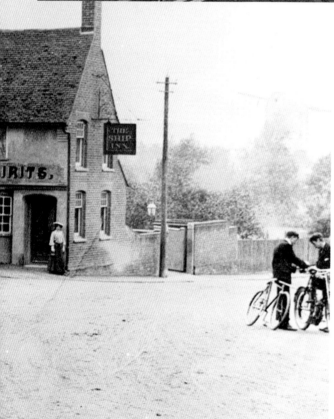

THE TRANQUIL PEACE and calm which allowed the roadsweeper to sweep up the horse manure, a couple of ladies in long dresses to saunter slowly across the road and two men to hold a discussion leaning on their bikes in the middle of the road in the old photograph has now given way to a very busy roundabout outside the Ship Inn, Great Clacton. Since the old photograph was taken, the original timber beams on The Ship have been exposed and the frontage returned to something approximating how it would have looked when first built. The Ship's two centuries-old association with the Cobbold Family came to an end in 2002 when Ridley's acquired Tolly Cobbold. It is now a Brewmaster Public House. (*Photograph by Linda Jacobs*)

BROMLEY'S MILL

CLACTON HAS SUFFERED a number of spectacular fires over the years. This one was at Bromley's Mill in Great Clacton in 1909. It is said that Henry Bromley, the owner, had been in London for the day and as his train approached Clacton he saw a red glow in the sky and wondered what was on fire. He soon found out!

AFTER THE DEVASTATING fire, Henry Bromley's steam mill was rebuilt but it soon went out of business. It stood empty for many years, until it was taken over by Dennis Heightman for his radio and electronics company, Denco. The company failed in 1946 but was bailed out

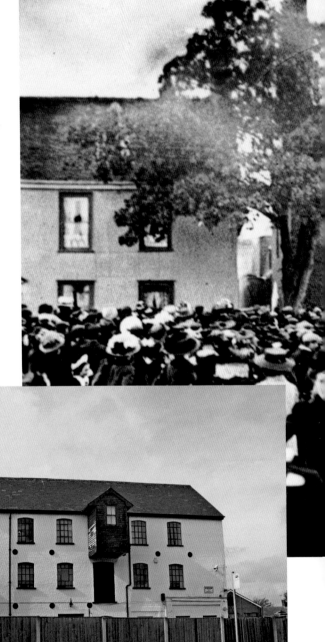

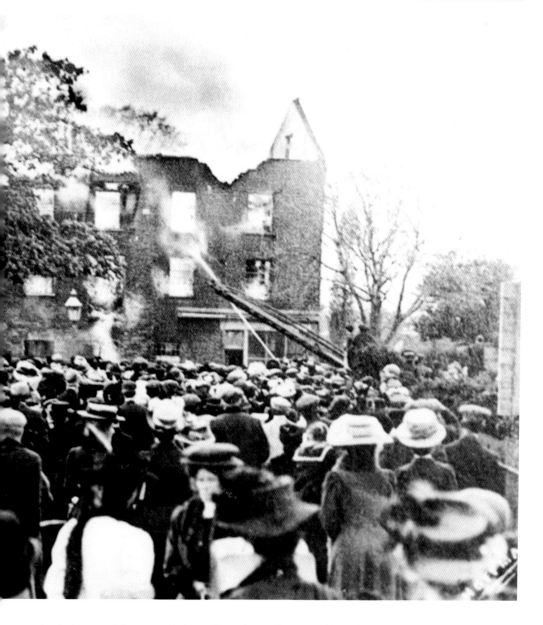

by their general foreman, Arthur Allwright. At the time of his take-over, his mode
of transport was a bicycle; by 1961 he was able to buy a Rolls-Royce Silver Cloud. So
popular was he as a boss that his employees clubbed together to pay for an advert in
the local paper congratulating him on his purchase. The old steam mill is currently
home to Bowens International Limited, photographic equipment and supplies.
(*Photograph by Linda Jacobs*)

MASCOT COURT

ANOTHER GREAT CLACTON fire was this one on 8 August 1921, which destroyed a number of shops, the maltings and a row of old cottages. It was one of the last outings for the old horse-drawn fire engine, as it was in 1921 that a decision was made to obtain a new motorized one.

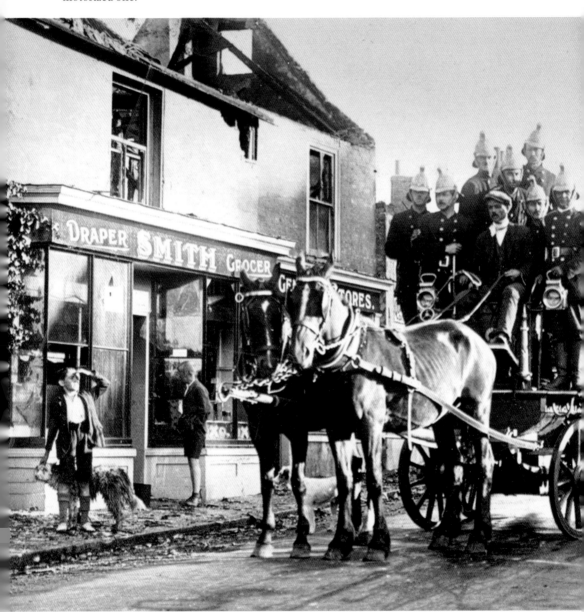

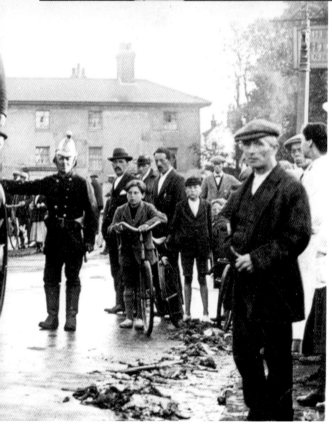

THE FIRE COMPLETELY destroyed the old maltings and, in 1922, a cinema, the Electric Theatre, was opened on the site. After its closure at the outbreak of the Second World War, the building was converted into a clothing factory, Suswin's, who made protective clothing under the brand name 'Mascot'. When Suswin's finally went out of business the building was completely demolished. In its place a new housing development, Mascot Court, managed by the Housing Association, Colne Housing, with thirteen dwellings, was built on the site. It was opened by the chairman of Tendring District Council, Cllr John White, and the local MP, Ivan Henderson, in September 2002.
(*Photograph by Linda Jacobs*)

BURRSVILLE

IN 1932, CLACTON-ON-SEA began to
expand beyond the old village of Great
Clacton when William Renshaw built up
the Burrsville Park Estate, starting with
The Drive. By the start of the Second World
War, some 250 houses had been built,
mostly bungalows for retired people. The
photograph on the right shows the corner
of Burrs Road and Gorse Lane in 1940.

BURRSVILLE CONTINUED TO expand
throughout the 1950s and 1960s and
the once-rural setting of this corner of
Burrs Road and Gorse Lane has completely
disappeared. Houses now spread all the
way along Burrs Road, and behind the
bungalow to the right can just be seen
the beginning of the large Gorse Lane
Industrial Estate (which includes the
Clacton Factory Outlet, a large shopping

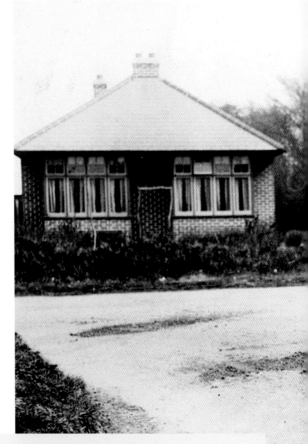

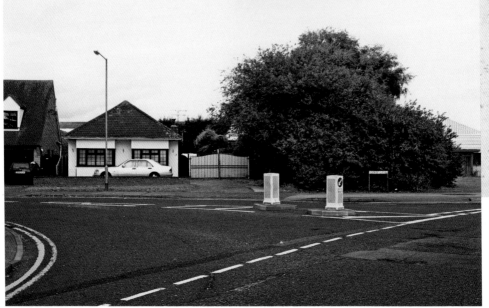

complex which includes a wide range of individual stores with famous name brands in fashion, footwear, sportswear, household items, outdoor equipment and many other items). The spot from where the modern photo was taken now includes a small row of shops including a post office, a hairdresser and a convenience store to cater for the growing community.
(*Photograph by Linda Jacobs*)

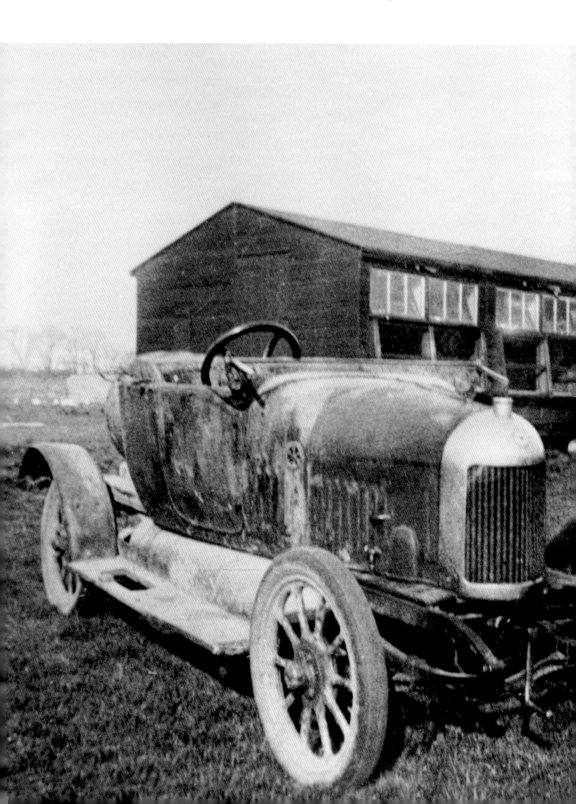

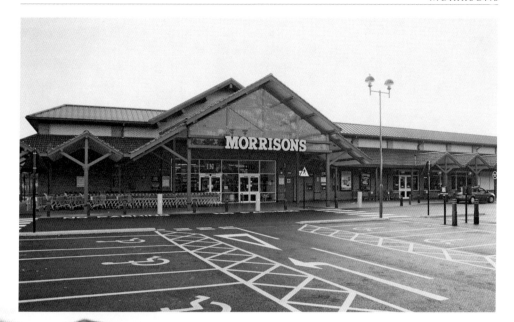

BEFORE THE LITTLE Clacton Safeway store was built, the land belonged to the Horsefall family, who kept a poultry farm on the site. The photograph on the left shows the farm in the early 1930s. The car is a Bullnose Morris Cowley, which was bought by the farmer for £12 and used mainly for transporting chicken feed around the farm.

AT THE END of the 1930s, Everitt's Sweet Pea Nurseries took over the Horsefall family's land and marked out most of it as a tennis court, known as White Gates, for use by the staff. When Everitt's closed in 1972, their land was sold off to Highfield's Holiday Park, except for the former Horsefall family land which reverted to the Horsefall family. In the mid-1990s, they sold it to Britton Construction, who, in turn, sold the land to Safeway, who opened a new supermarket on the site in 1995. After Safeway was taken over by Morrisons in 2004, the shop became part of the Morrisons' chain.
(*Photograph by Linda Jacobs*)

DOT'S OF JAYWICK

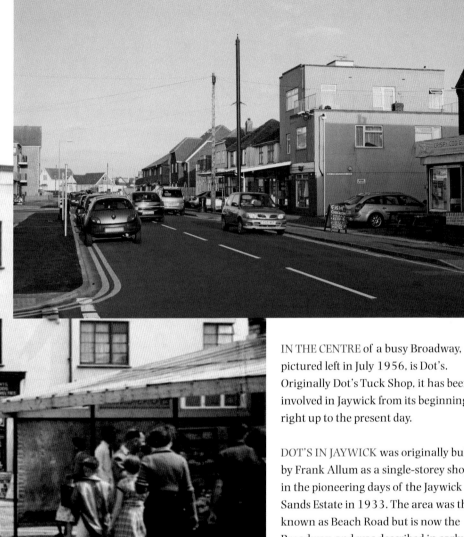

IN THE CENTRE of a busy Broadway, pictured left in July 1956, is Dot's. Originally Dot's Tuck Shop, it has been involved in Jaywick from its beginnings right up to the present day.

DOT'S IN JAYWICK was originally built by Frank Allum as a single-storey shop in the pioneering days of the Jaywick Sands Estate in 1933. The area was then known as Beach Road but is now the Broadway, and was described in early guides as selling 'High class confectionery, tobacco and cigarettes, stationery, post cards, novels, etc.' The two floors above were added in 1935. In 1991 a two-storey extension – built to increase the size of the shop as well as the flat above – was added down the Sea Cornflower Road frontage. Sadly, the open-top double-decker no longer runs along the sea front from Clacton to Jaywick.
(*Photograph by Linda Jacobs*)

THE CAFÉ MOROCCO

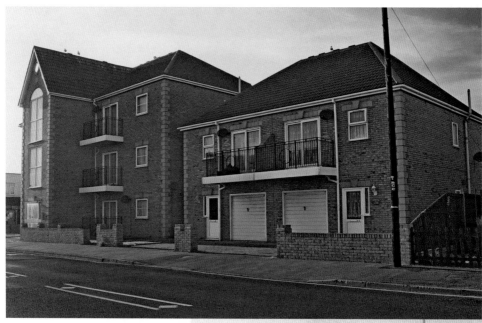

THE CAFÉ MOROCCO, seen on the right in the 1930s, was built in 1934 as a dance hall and called the Morocco Café Ballroom. After the war it became known as the Nightspot on Broadway. In 1980 it became a late-night disco called the Metro Club and in 1984 it became the Morocco Social Club. It closed down in 1987 and was demolished in 1991.

THE CAFÉ OCCUPIED the site on the right-hand side of Golf Green Road where it bends to the right. After the Morocco Social Club closed down in 1987, the ground-floor area became a Chinese restaurant, but this too shut down only a year later,

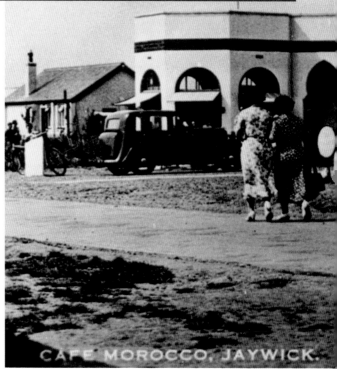

CAFÉ MOROCCO, JAYWICK.

leaving the building to gather dust and graffiti. It was eventually bought in 1990 by Mr Thurston, who demolished it in 1991. In its place arose the block of flats that can be seen in the modern photograph on the left; the flats are known as Barclay Square.
(*Photograph by Linda Jacobs*)

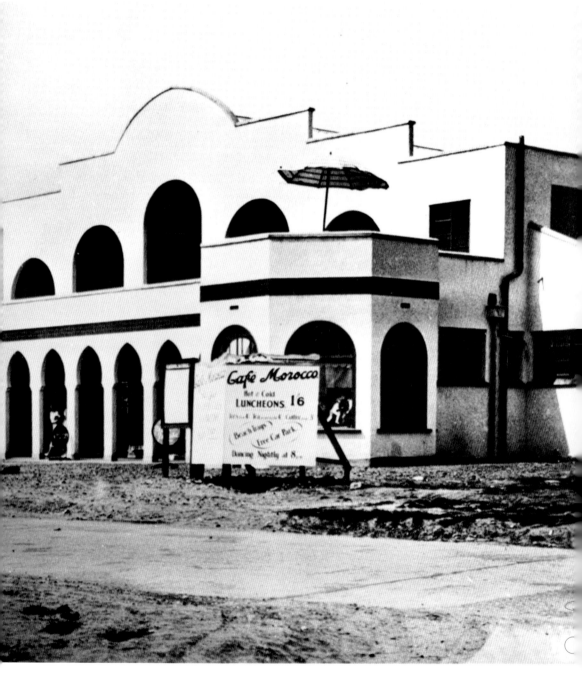

FRINTON ROAD, HOLLAND-ON-SEA

THE PHOTOGRAPH BELOW, taken in the 1920s, shows the original corrugated iron church of St Bartholomew's, which was dedicated in 1903. It was replaced in 1929 by a second

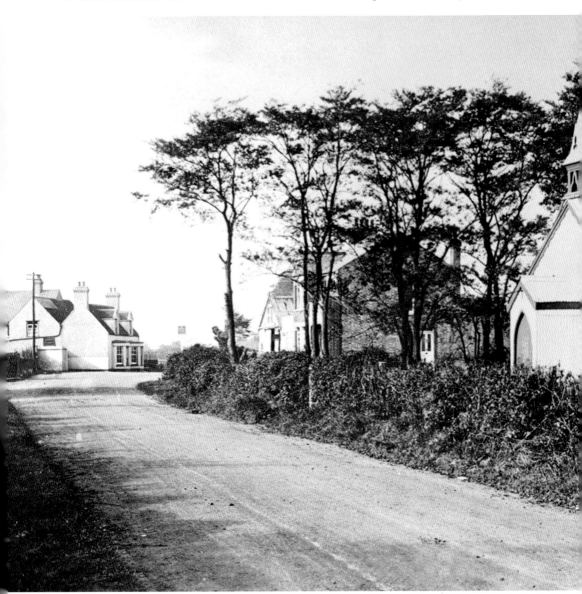

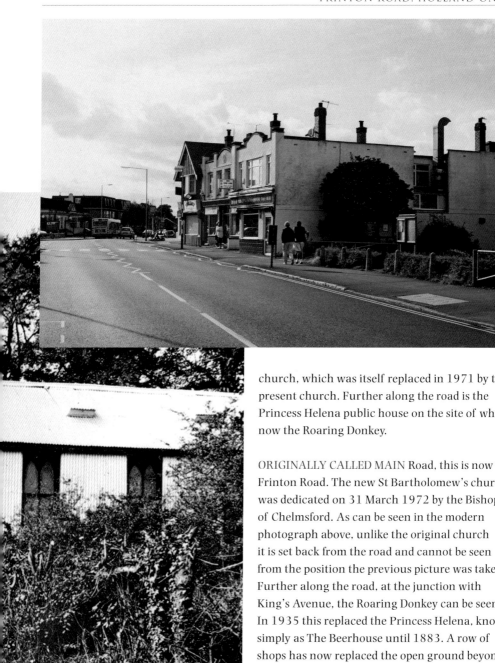

church, which was itself replaced in 1971 by the present church. Further along the road is the Princess Helena public house on the site of what is now the Roaring Donkey.

ORIGINALLY CALLED MAIN Road, this is now Frinton Road. The new St Bartholomew's church was dedicated on 31 March 1972 by the Bishop of Chelmsford. As can be seen in the modern photograph above, unlike the original church it is set back from the road and cannot be seen from the position the previous picture was taken. Further along the road, at the junction with King's Avenue, the Roaring Donkey can be seen. In 1935 this replaced the Princess Helena, known simply as The Beerhouse until 1883. A row of shops has now replaced the open ground beyond the church, with further buildings beyond the Roaring Donkey showing how this area has been built up since the coming of Holland-on-Sea in the 1920s and '30s.

(Photograph by Linda Jacobs)

QUEEN'S HALL THEATRE

THE QUEEN'S HALL at the bottom of King's Avenue opened in 1935 and can be seen below in the 1950s. The Queen's was a popular local theatre, putting on many first-class shows.

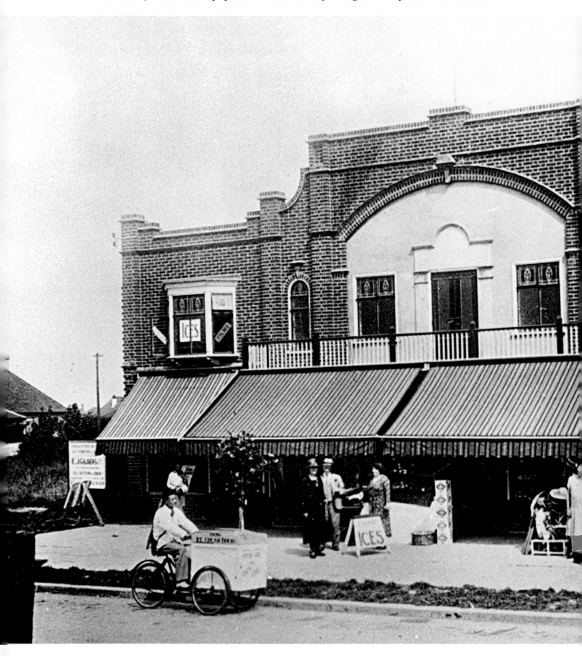

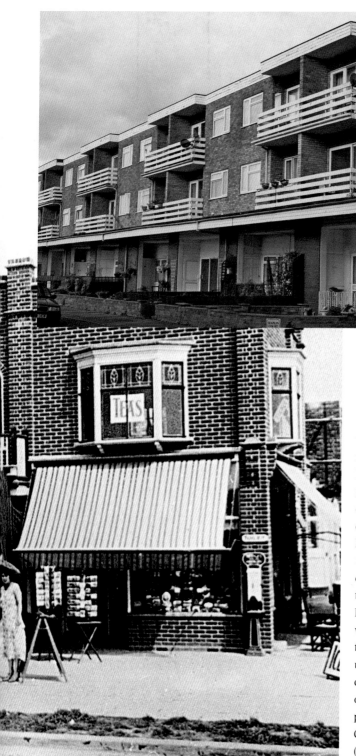

AS HOLLAND-ON-SEA continued to grow as a small seaside resort both immediately before and just after the Second World War, the Queen's Hall provided a much frequented venue for holidaymakers and residents, putting on a summer season of variety shows together with dances and whist drives. As the holiday trade declined in the 1960s, in common with many other seaside resorts around the country, so the Queen's Hall began to fall into disuse. It was eventually taken over by the National Health Service for use as offices and completely demolished in 1972. The block of flats shown in the modern photograph above, Maplin Court, took its place.
(*Photograph by Linda Jacobs*)

WEST BEACH FROM
THE PIER

THE CROWDED EDWARDIAN beach scene below, photographed in around 1910, shows that even when the tide was in there was still plenty to do. The building on the right was a sea-water pumping station, built in 1899 to pump water round to standpipes dotted around the town for council workmen to wash down the dusty streets. It was demolished in 1963.

THE MODERN PHOTOGRAPH on the right shows that Clacton is still a popular holiday destination today, with crowds flocking to the beach even as late as October, when this

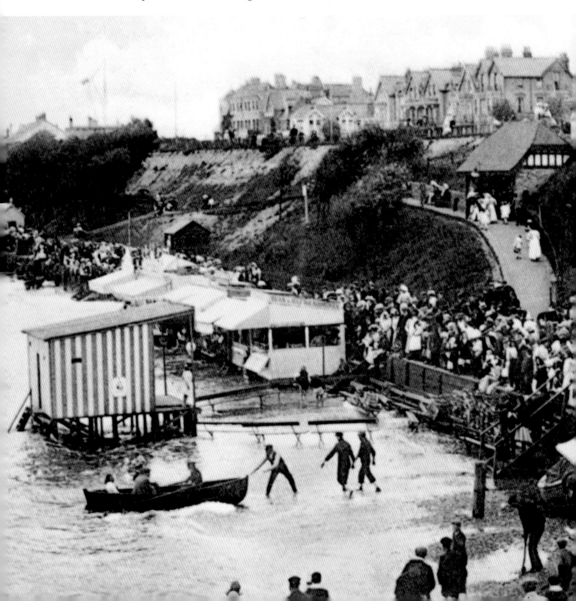

photograph was taken. After the sea-water pumping station was demolished in 1963 it was replaced by the Atlanta Restaurant, which many Clactonians remember for its model racing-car circuit. The restaurant closed a few years ago, leaving just the souvenir and refreshments establishments on the ground floor. The beach itself is holder of the Quality Coast Award with the added bonus of the operation of Clacton's pioneering child safety colour-coded wristband scheme, making it easier to reunite parents with lost children. (*Photograph by Linda Jacobs*)

67

WEST BEACH

BACK ON THE west beach, next to the pier, *c*.1910. The crowds seem to be watching the arrival of the lifeboat, the *Albert Edward*, the third lifeboat to be given the same name. In the foreground

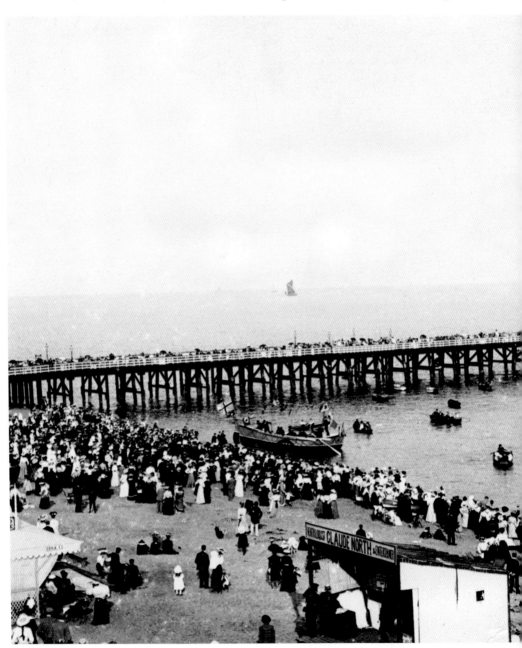

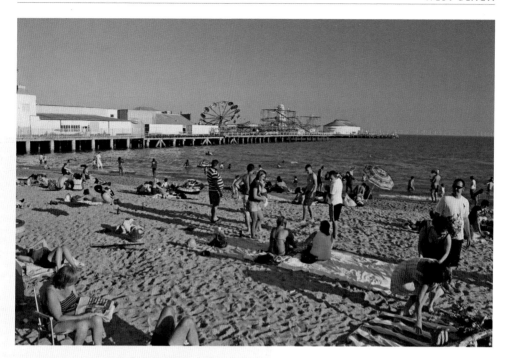

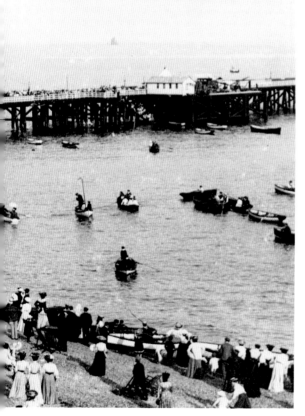

is Claude North's 'Living and String Marionettes' stand. His son, Claude North Junior, continued the tradition until well after the Second World War by operating a Punch and Judy show on the same spot.

IN THE BACKGROUND of the modern photograph above, the pier has changed beyond all recognition, having been extended and widened several times over the years to become the largest pier in the country. It now has many buildings and rides for all ages, including the new roller coaster, 'Stella's Revenge', recalling the Steel Stella which stood on the pier from 1937 until it was burnt down in 1973. Out at sea, the new wind farm, now a prominent feature of the view from the beach, can be seen. Sadly, though, the Punch and Judy stand no longer graces the beach.

(*Photograph by Linda Jacobs*)

EAST BEACH

THE EAST BEACH has never been as popular as the west beach. Nevertheless, the photograph on the right, taken in around 1905, shows a certain amount of activity on the beach as well as a small band playing to the holidaymakers. Jack Holland's Concert Party were regular performers on this stretch of beach.

THE ASPECT OF the beach immediately to the east of the pier underwent a radical transformation when the glass-fronted band pavilion was opened in 1914 as part of the town's 'General Beautifying Programme', to protect the crowds

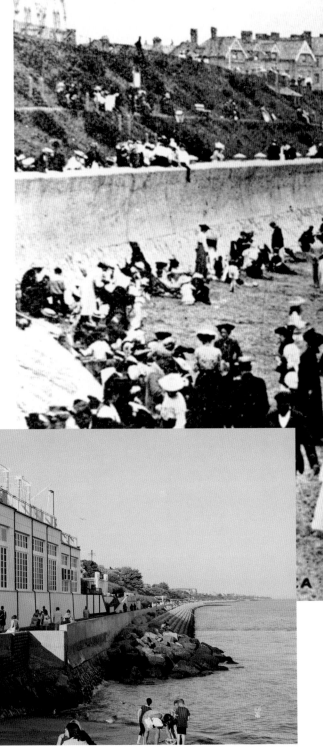

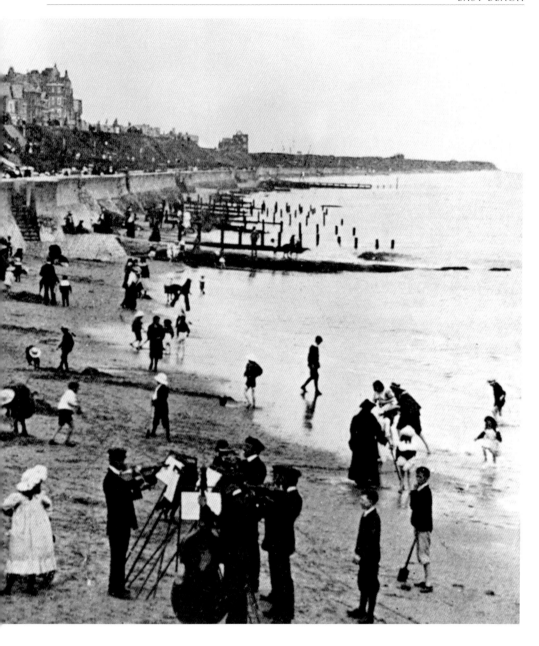

attending band concerts at the bandstand from the strong winds that sometimes blow in from the North Sea. The view was further changed in the 1990s when new sea-defences were built to prevent erosion – defences which made it very difficult to gain access to the beach. A road train now runs along the lower promenade from this point up to Lilly Farm Beach just about on the border between Clacton and Holland.

(*Photograph by Linda Jacobs*)

LILLEY FARM BEACH

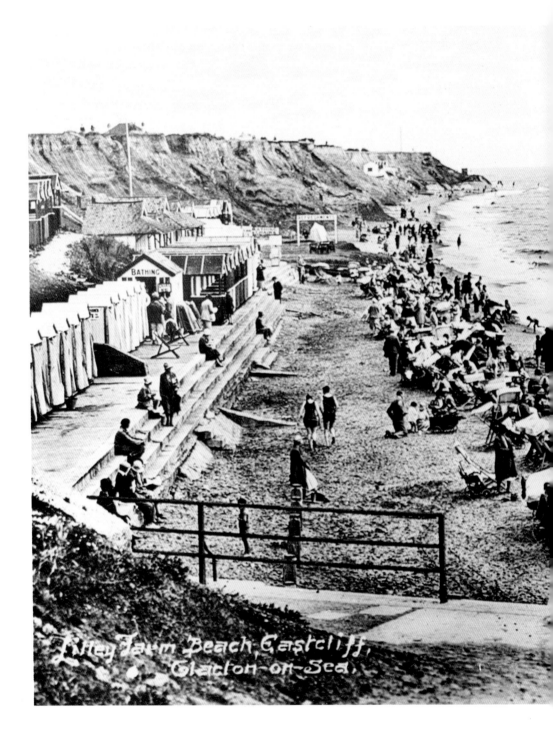

Lilley Farm Beach, Eastcliff, Clacton-on-Sea.

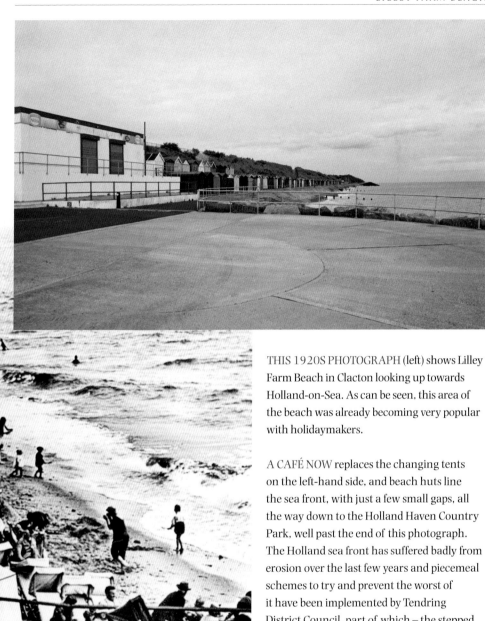

THIS 1920S PHOTOGRAPH (left) shows Lilley Farm Beach in Clacton looking up towards Holland-on-Sea. As can be seen, this area of the beach was already becoming very popular with holidaymakers.

A CAFÉ NOW replaces the changing tents on the left-hand side, and beach huts line the sea front, with just a few small gaps, all the way down to the Holland Haven Country Park, well past the end of this photograph. The Holland sea front has suffered badly from erosion over the last few years and piecemeal schemes to try and prevent the worst of it have been implemented by Tendring District Council, part of which – the stepped revetment – can be seen in the photograph above. But it really needs a multi-million pound scheme – which the council can't afford – if the Holland sea front is to be saved for future generations. The large turning circle in the foreground is used by the road train to turn round at the end of its journey. (*Photograph by Linda Jacobs*)

THE JETTY

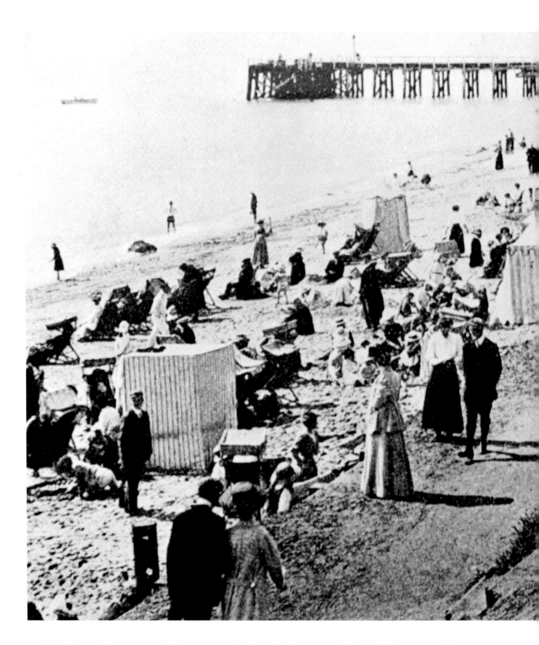

IN 1898 A smaller version of the pier was built at the far west end. Called the Jetty, and seen in the photograph above in around 1908, it was supposed to have been used for the barges bringing building materials to the new town of Clacton. But it was not used much and became a small pleasure pier between the wars. It was demolished in 1940 as a wartime precaution.

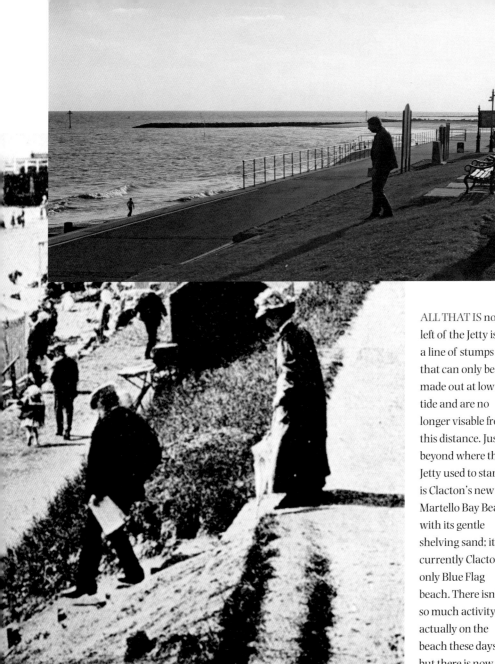

CLACTON - ON - SEA

ALL THAT IS now left of the Jetty is a line of stumps that can only be made out at low tide and are no longer visable from this distance. Just beyond where the Jetty used to stand is Clacton's new Martello Bay Beach with its gentle shelving sand; it is currently Clacton's only Blue Flag beach. There isn't so much activity actually on the beach these days, but there is now the Greensward Café, to the right at the end of the greensward, and just beyond that the Martello Inn. There is also a new slipway down to the beach in the foreground. The pathway through the greensward down to the lower promenade, now properly made up and tarmacked, is covered over by grass. (*Photograph by Linda Jacobs*)

ON THE
PIER

WHEN THE PHOTOGRAPH on the right
was taken in 1872 this is practically all
there was of Clacton-on-Sea: the pier and
the Royal Hotel sitting alone on the clifftop.

TAKEN FROM ROUGHLY the same
position, there is now no possibility of
seeing the Royal Hotel looking back up
the pier any more. Built originally purely
as a landing stage in 1871 for paddle
steamers from London, the pier underwent
a radical transformation after being
bought by Ernest Kingsman at the end of
the First World War. He decided its future
lay in turning it into an amusement and
entertainment centre. He spent hundreds
of thousands of pounds on it between

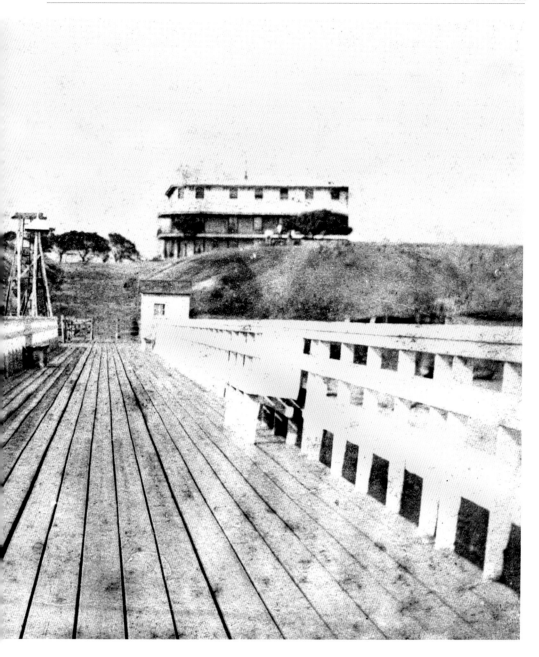

the wars, turning it into a major tourist attraction which was largely responsible for propelling Clacton into the top rank of British seaside resorts – up there with the likes of Blackpool and Brighton. On the left, the red-and-white building was built in 1928 as the Ocean Theatre. Having closed in 1978, it is now an amusement arcade.

(*Photograph by Linda Jacobs*)

THE JOLLY ROGER

DURING THE EDWARDIAN period the pier pavilion was home to a concert party, under the direction of Will Pepper, called (entirely politically incorrectly by today's standards) the 'White Coons'. Note the lovely ornate street lamps dotted along the pier in the old photograph below.

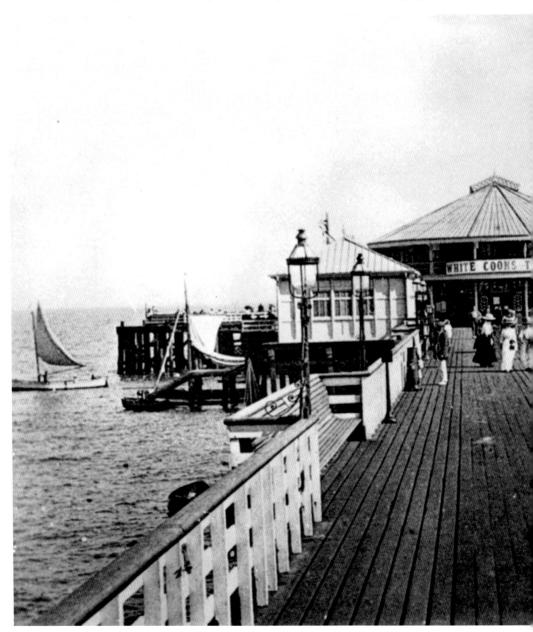

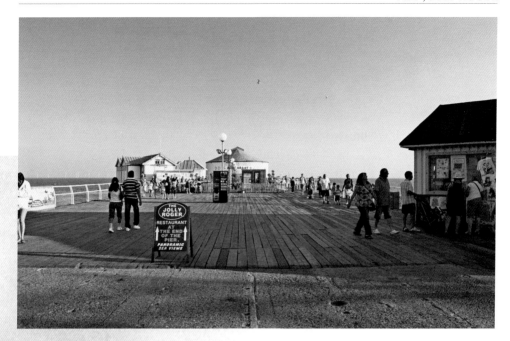

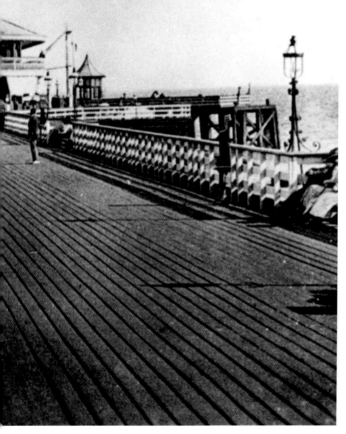

UNDER ERNEST KINGSMAN, the pier pavilion was renamed the Jolly Roger and continued to operate as a theatre until 1964, when the Ramblas Open Air Concert Party – who used the theatre for their evening performances or on those extremely rare occasions in Clacton when it was wet – folded. The theatre closed and, for a while, became a circus ring but then fell into disuse and remained derelict for some time. Part of it is now in use as a restaurant. The pier is still Clacton's major tourist attraction and the new owners, Billy and Elliot Ball, have made a major investment in it, adding many new attractions to keep it that way, including the new 'adventure crazy golf course', which can be seen in the middle distance, and a six-lane bowling alley.

(*Photograph by Linda Jacobs*)

RAILWAY STATION, OUTSIDE

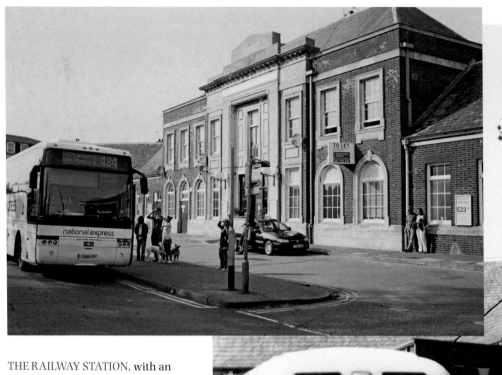

THE RAILWAY STATION, with an Eastern National bus outside, can be seen on the right in 1955 – a period when public transport was still a more popular means of getting to Clacton than the car. Summer Saturdays at the station were always very busy.

STILL THE SAME station building, but buses no longer pull into the slip road, as can be seen in this photograph of a National Express bus, bound for London, stopping in the main road outside the station. The canopy proudly displaying the large Clacton-on-Sea sign has gone, replaced by a small, almost apologetic sign just saying 'Clacton', high up on the façade. With more and more

families owning cars, the station is now used mainly by commuters to Colchester and London rather than by holidaymakers, and is at its busiest during the Monday to Friday rush hour rather than at weekends.
(*Photograph by Linda Jacobs*)

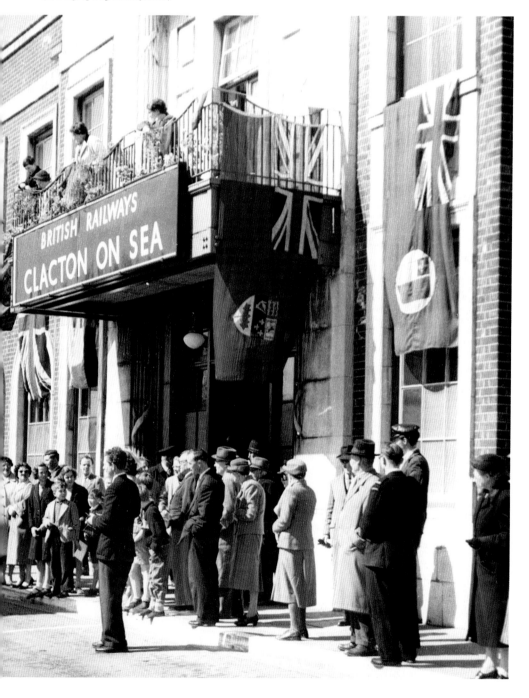

RAILWAY STATION, INSIDE

IN 1959, THE date of the photograph on the right, WHSmith still had a bookstall inside Clacton station. On the board to the right of the Vimaltol advert is an announcement concerning the forthcoming electrification of the service to Colchester.

THE ONCE-BUSY inside of the station looks almost deserted in the modern photograph below. The large display boards have been replaced by overhead monitors displaying arrival and departure information, while stalls like the WHSmith stand in the old photograph

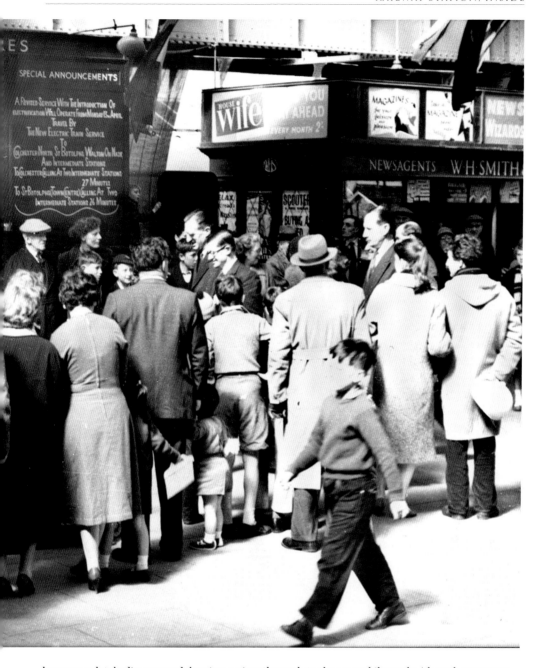

have completely disappeared, leaving a view through to the many bike racks (though not many bikes!), clear daylight and the trains. The electrification of the line, which is being announced on the notice boards in the 1959 photograph, originally ran only as far as Colchester. Full electrification of the line to London wasn't completed until 1962, in which year the first electric services to and from London started.

(*Photograph by Linda Jacobs*)

WEST CLIFF THEATRE

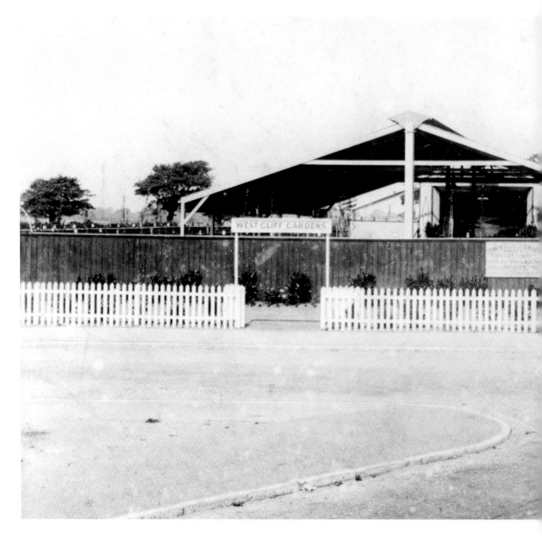

THE OLD WEST Cliff Gardens Theatre, seen above around 1905, was made of wood and canvas and the sides could be rolled up on hot summer evenings to let the air in. The present West Cliff Theatre was built on the same site in 1928 and is, of course, still going strong today.

SINCE BEING BUILT in 1928, the West Cliff Theatre has gone from strength to strength. It is one of only six or seven theatres around the country which still puts on a summer variety season. In the late 1940s the number was well in excess of 200. It also puts on many other professional shows and amateur performances, including those put on by its own Theatre Youth Group. Although the entrance is now on Tower Road rather than Freeland Road as in the earlier photograph, the

alignment of the auditorium has remained the same since the open-air stage was first erected in 1899. In the background, St James's church, built in 1913, is now a prominent feature of the skyline. (*Photograph by Linda Jacobs*)

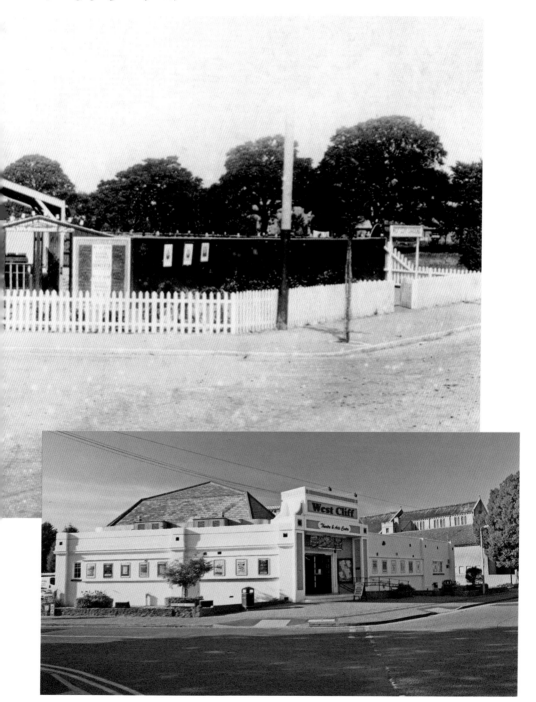

THE BANDSTAND

IN 1899 A bandstand was built on the East Promenade opposite the Royal Hotel for the town band and visiting German bands. This photograph was taken around 1910, at which time the conductor was George Wright, whose favourite tune was *Poet & Peasant*.

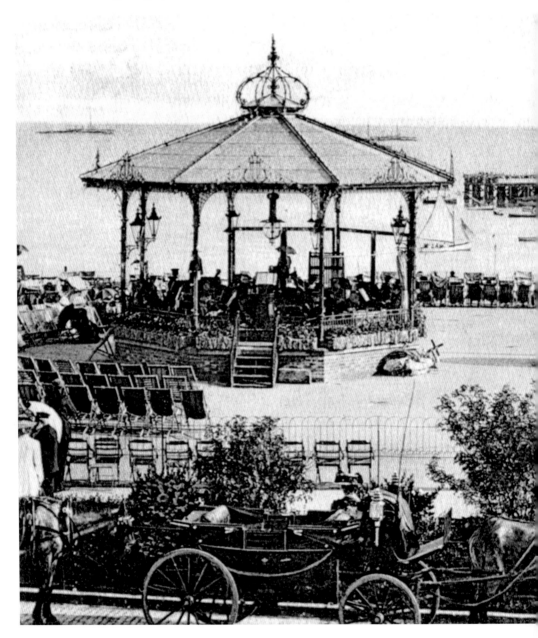

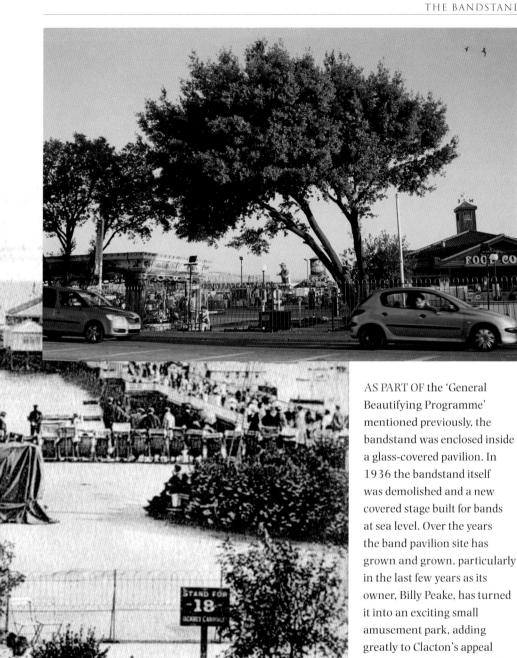

AS PART OF the 'General Beautifying Programme' mentioned previously, the bandstand was enclosed inside a glass-covered pavilion. In 1936 the bandstand itself was demolished and a new covered stage built for bands at sea level. Over the years the band pavilion site has grown and grown, particularly in the last few years as its owner, Billy Peake, has turned it into an exciting small amusement park, adding greatly to Clacton's appeal to youngsters. Today the old band theatre stage has been covered over and is no longer visible, but construction of a new bowling alley on the site is now underway. (*Photograph by Linda Jacobs*)

WAVERLEY HOTEL

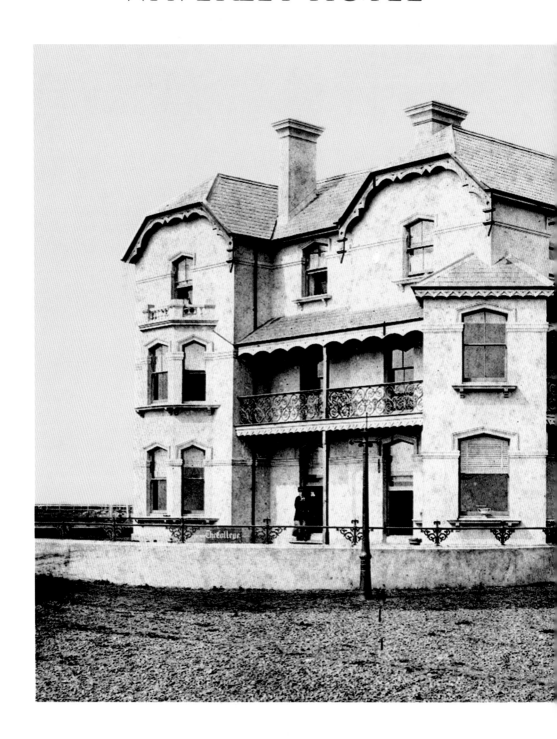

IN THE EARLY days of the resort many schools and colleges were established, as the bracing sea air was felt to be an aid to education. The College, seen here shortly after its foundation in 1881, was one such boys' school. About ten years later it was converted into the Waverley Hotel.

ALTHOUGH IT HAS changed its name a couple of times in the last decade, as firstly it became part of the Days Inn chain and then the Comfort Hotel, as part of the Comfort chain, the Waverley is the oldest hotel to remain open for that purpose in Clacton. The original building is still exactly as it was but there have been a number of extensions, particularly along the Agate Road frontage and on the front of the hotel. A new restaurant, the Blue Lagoon Indian Tapas & Grill, has been added. It is also no longer an isolated building as in the old photograph, but by a busy roundabout in the middle of a built-up area.

(*Photograph by Linda Jacobs*)

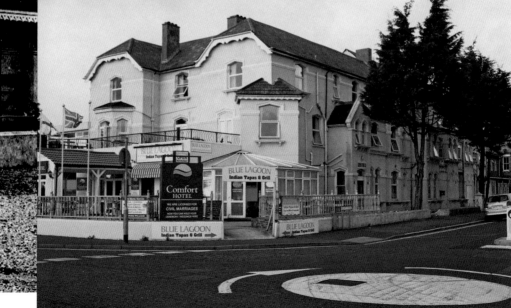

BUTLIN'S

BILLY BUTLIN OPENED his first camp in Skegness in 1936 and his second in Clacton in 1938. When it first opened it catered for 1,000 visitors. This view of the Clacton camp swimming pool dates from 1939.

BUTLIN'S HOLIDAY CAMP, Clacton lasted until 1983, by which time it was catering for 6,000 campers. Butlin's, by then owned by the Rank Organisation, had decided to revamp most of their sites to become holiday villages or holiday centres as the idea of 'holiday camps' had become outmoded. Sadly, Clacton was not included in this revamp as it

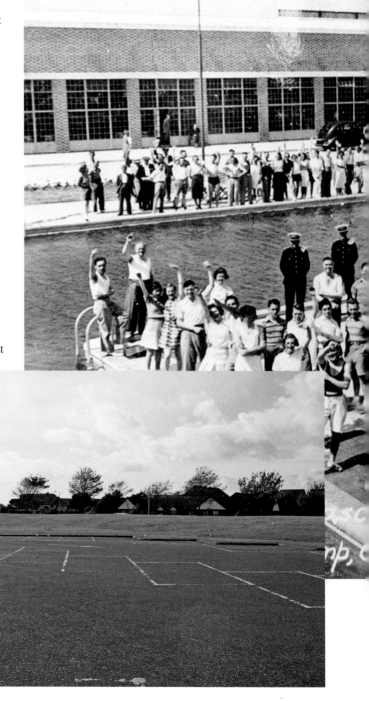

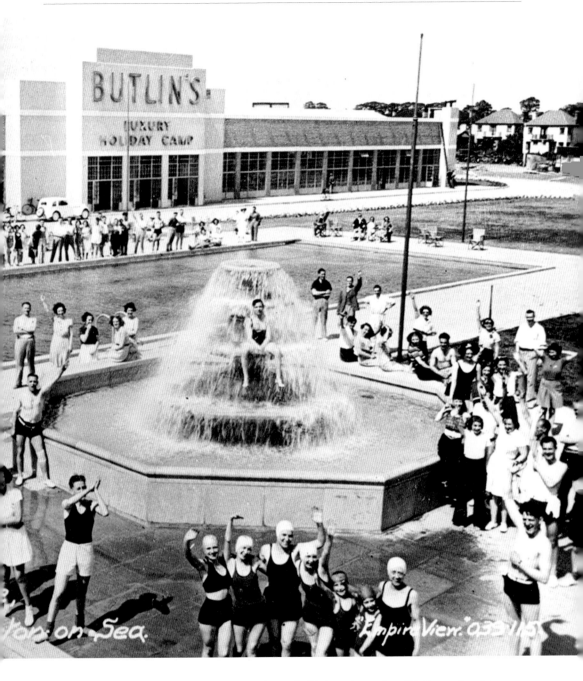

was said to be losing money year on year so, instead of being given a face lift, it was closed down. A short-lived American-style theme park, Atlas Park, took its place for one year, but it was then turned over to developers and the majority of the site is now a housing estate with a large coach park and the new lifeboat station, seen to the left of the modern photograph. (*Photograph by Linda Jacobs*)

THE *CLACTON GAZETTE*

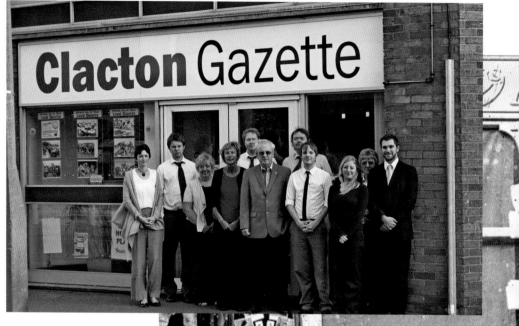

ABRAHAM QUICK AND Co.
Ltd published the *Clacton
News* and its successor,
the *East Essex Gazette*, for
around seventy-five years.
The photograph on the right
shows the staff outside its
first office in Station Road,
where visitors could be
'conducted over the premises
on presentation of a card',
in 1890. Abraham Quick
himself is seated fourth from
the right in the front row.

FOUNDED IN 1889, the
Clacton Gazette, originally
the *Clacton News* and then
the *East Essex Gazette*, has
been the main newspaper

for the Clacton area for 123 years. In that time its offices have moved from Station Road to Jackson Road (where the Travelodge hotel now is), and finally to its present offices, also in Jackson Road but on the opposite side. It is interesting to note that all twenty-two staff in the first photograph are male (and all wearing hats!), whereas in the modern picture over half are female. Like his predecessor, the current editor, Brendan Hanrahan, is situated fourth from the right on the front row.
(*Photograph by Linda Jacobs*)

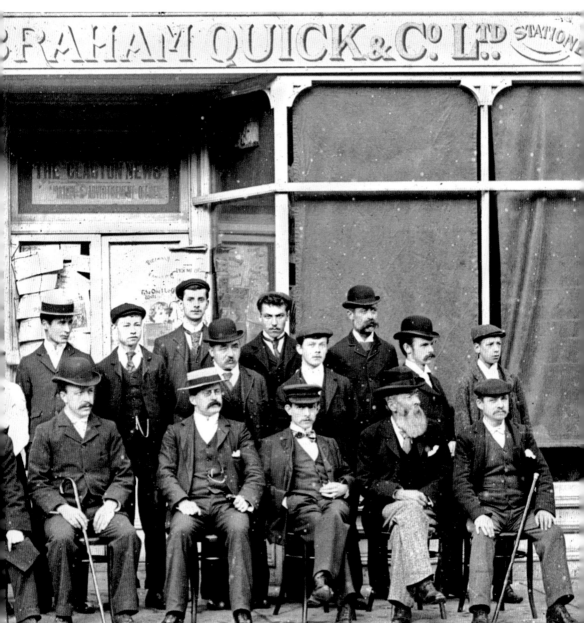

THE CARNIVAL

THE CARNIVAL WAS first held in 1922 by Ernest Kingsman as a fundraising event for Clacton Hospital. The most popular part of the carnival has always been the procession. The photograph on the right shows the Oulton Hall entry in the late 1930s.

THE CARNIVAL WENT on to become one of Clacton's major tourist attractions, with the procession being held in early August at the peak of the holiday season, and still raises funds for many local charities. At its height there were something like forty

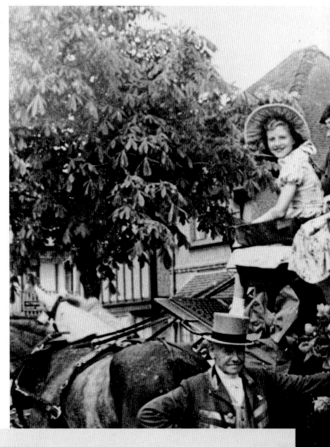

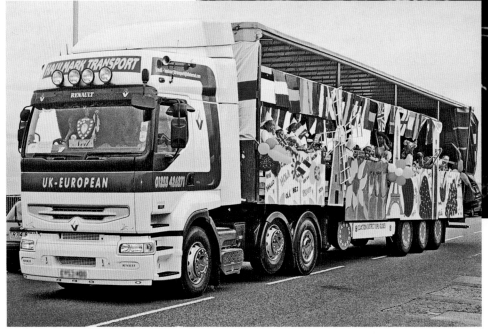

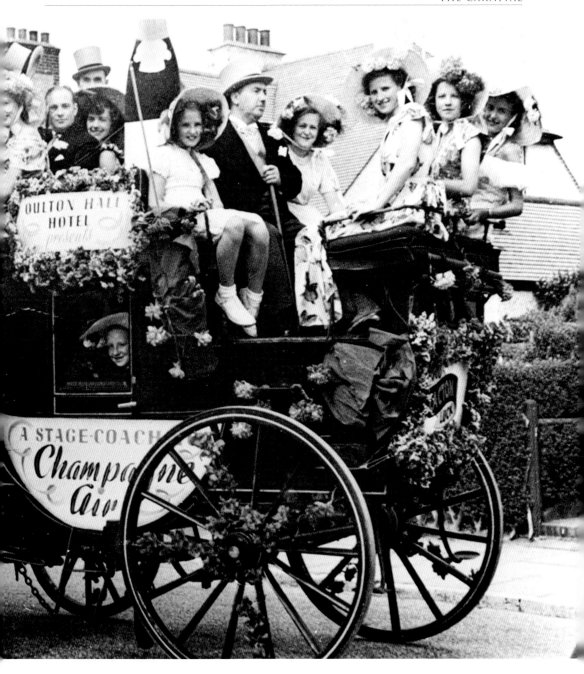

floats taking part, about twenty of which were provided by Butlin's. The closure of Butlin's dealt a big blow to the procession but in the last ten years or so its popularity has grown with more and more floats taking part – and, as can be seen in the modern photograph, they are a lot bigger than they were in the 1930s! This is the Clacton District Girl Guides Float in the 2011 procession. (*Photograph by the author*)

Other titles published by The History Press

More Essex Murders

LINDA STRATMANN

From the pretty villages, rural byways and bustling market towns of Essex come ten of the most dramatic and tragic murder cases in British history. Brutality, passion, jealousy, greed and moments of inexplicable rage have led to violent and horrifying deaths and, sometimes, the killer's expiation of the crime on the scaffold. This chilling follow-up to *Essex Murders* brings together more true cases, dating between 1823 and 1960, that shocked not only the county but also made headline news across the nation.

978 0 7524 5850 2

Paranormal Essex

JASON DAY

A tour around one of England's oldest and most paranormally active counties. Visit the site of the 'Most Haunted House In England' at Borley, encounter the mysterious Spider of Stock, witness an RAF pilot's shocking near miss with a UFO over the skies of Southend, and find out how the infamous 'Witchfinder General' served as judge, jury and executioner in Manningtree. With accounts of hauntings, monsters, UFOs, Big Cats, and more. *Paranormal Essex* will delight all lovers of the unexplained.

978 0 7524 5527 3

Exploring Historical Essex

ROBERT LEADER

This engaging guidebook paints a comprehensive picture of Essex, bringing the reader on an exploratory journey from Brightlingsea to Wivenhoe whilst uncovering the secrets and history this fine county has to offer. Serving as both an inspiring guide and a lasting souvenir, this book is richly illustrated with the author's photographs, bringing historical Essex to life.

978 0 7524 5764 2

A Schoolboy's War in Essex

DAVID F. WOOD

Although only children at the time, the Second World War had a permanent effect on the schoolboys who lived through the conflict. Watching a country preparing for war and then being immersed in the horrors of the Blitz brought encounters and events that some will never forget. Now in their seventies and eighties, many are revisiting their memories of this period for the first time. In this charming book, David F. Wood recalls his days as a schoolboy in Essex, where his family moved when the Luftwaffe threatened his native London.

978 0 7524 5517 4

Visit our website and discover thousands of other History Press books.

www.thehistorypress.co.uk

The History Press